Images of America
Spearfish National Fish Hatchery

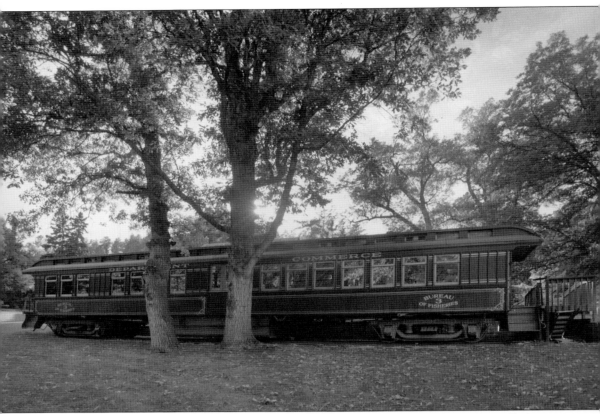

On display at the D.C. Booth Historic National Fish Hatchery and Archives (formally known as Spearfish National Fish Hatchery), the beautiful replica of Bureau of Fisheries Fish Car No. 3 represents the era when railroad cars were used to transport fish across the country. Thanks to U.S. Fish and Wildlife Service volunteers providing informational tours, visitors can get a sense of what it was like for crews to live and work in the confines of a railcar. This replica is based on a 1910 passenger car and was made possible in part thanks to an 1897 scale model housed in the D.C. Booth archives. (Les Voorhis.)

ON THE COVER: Forest ranger Frank T. "Cap" Smith pours water from Bear Butte Creek into milk cans filled with trout fingerlings to help the fish avoid temperature shock when poured into their new home. Milk cans were commonly used to carry fish from hatcheries in the early 20th century. These cans of fish made their way by rail from Spearfish National Fish Hatchery, then by buckboard to the creek, and perhaps eventually into an angler's creel. (Black Hills National Forest.)

IMAGES of America
SPEARFISH NATIONAL FISH HATCHERY

Booth Society, Inc.
Foreword by Arden Trandahl

Copyright © 2013 by Booth Society, Inc., with a foreword by Arden Trandahl
ISBN 978-1-4671-1008-2

Published by Arcadia Publishing
Charleston, South Carolina

Printed in the United States of America

Library of Congress Control Number: 2013930272

For all general information, please contact Arcadia Publishing:
Telephone 843-853-2070
Fax 843-853-0044
E-mail sales@arcadiapublishing.com
For customer service and orders:
Toll-Free 1-888-313-2665

Visit us on the Internet at www.arcadiapublishing.com

This book is humbly dedicated to the scores of men and women (and their families) who have worked to conserve America's fisheries since 1871 under the banners of the US Fish Commission, the US Bureau of Fisheries, and today's US Fish and Wildlife Service.

Contents

Foreword ... 6

Acknowledgments ... 7

Introduction ... 8

1. In the Beginning ... 11
2. At Home on the Hatchery ... 55
3. Hatchery History in Postcards ... 81
4. Era of Change ... 85
5. A New Mission ... 103

About the Booth Society, Inc. ... 127

Foreword

We live our lives in seasons. Days yield to months, months give way to years, and before we know it, the press of time has left a vast landscape behind us on the meandering paths that we have traveled. I came to Spearfish, South Dakota, going on 35 years ago in the season of my early middle years. Since the late 1800s, Spearfish National Fish Hatchery and its namesake town had been, in the culture of the US Fish and Wildlife Service, a "choice assignment." I was pleased as punch to pull up stakes back east and move my beautiful wife, Sylvia, my strongest supporter, and our nine children to the northern Black Hills. I took a pay cut to come here—and I am glad that I did.

Raising trout and supervising fish diet research and training were challenges in fisheries conservation that the previous decades of experience and education had prepared me for, and I waded into it chest-deep as supervisor of the Spearfish hatchery and its attendant substations. I was not, however, prepared to close down one of the oldest national fish hatcheries in the country; but that is exactly what I eventually was told to do. A setting sun casts long shadows, and I must admit this was a dark time.

Thankfully, the town folks cared enough to keep up the place as the tourist destination that it was—and had been from the very beginning. Something transcendent had already happened, I now see, that would send this beautiful place into its next season. Fisheries workers in the US Fish and Wildlife Service, mostly working in the Rocky Mountain West, had started to send important archival matter here in the 1970s. Ancient glass-plate photograph negatives, 100-year-old reports, and old objects and such found a loving home here and were the kernel that blossomed into the exceptional archives that we have today. It is one of a kind, the world over. I find it very heartening to see students, scholars, scientists, and historians come here to research a particular question or to seek out records or objects that will guide future decisions. The future is, after all, an amalgam of all its yesterdays.

Many popular history books are but a coda on a song, drawing creations to a close, but not this book. This tribute to the past is about the future—it is about a new season and a new mission. I have seen enough to tell you that past is not prologue, it is the very substance of the future. And, so it will be for the D.C. Booth Historic National Fish Hatchery and Archives.

—Arden Trandahl
Spearfish, South Dakota

Acknowledgments

The Booth Society, Inc. would like to sincerely thank the US Fish and Wildlife Service, which originated as the US Fish Commission in 1871 and is recognized as the oldest conservation agency in the country. This book would not have been possible without the collections located within the archives at the D.C. Booth Historic National Fish Hatchery. Established in 1896, the Spearfish Fish Cultural Station is now the service's fisheries archive. We greatly appreciate those who had the foresight to send the first historic fisheries collections to Spearfish in the late 1970s, and the volunteers and staff who throughout the years and today contribute in countless ways. Specifically, we want to recognize Carlos R. Martinez, director of the D.C. Booth Historic National Fish Hatchery and Archives, for his progressive thinking and proactive visions; Craig Springer, writer and editor of the service's *Eddies* magazine, for his advice and assistance with this book; and D.C. Booth curator Randi Sue Smith for maintaining and protecting the archives for the last 21 years. With an estimated 175,000 items, Spearfish is a treasure and a hidden gem. Nearly all of the images used in this book came from the archives. Those that did not were provided by the Fassbender Collection, Black Hills National Forest, Black Hills State University, Custer State Park, the Library of Congress, Les Voorhis, Jon Crane, Ned Kirstein, South Dakota State Historical Society, the University of Washington's Freshwater and Marine Image Bank, and the US Secret Service. John Huffman, Jo and Larry Kallemeyn, Erin Heidelberger, and David Nickel contributed to this book in no small measure. It is an honor to serve as a Friends Group for a station and an agency with such a deep history.

—April Gregory, Executive Director
Booth Society, Inc.

INTRODUCTION

By some accounts, Barton Warren Evermann was a stern and pretentious man. He was a consummate man of science, and proudly so. As a young adult, he added an extra N to his name so that it sounded more Germanic, since German culture of his time was associated with scientific prowess. Evermann worked for the US Fish Commission, the forerunner of today's US Fish and Wildlife Service, as its chief of scientific inquiry. By a directive of Congress, he left his Washington, DC, office and traveled to the Black Hills of South Dakota in the early 1890s. He was particularly drawn to Spearfish. His visits, his findings, and his reports to Congress shaped the Black Hills into what it is today, with its pleasant purling waters.

In August 1892, Congress granted Evermann "for investigation and report, respecting the advisability of establishing fish-hatching stations at suitable points in the States of South Dakota, Iowa, and Nebraska, $1,000, or as much thereof as may be necessary." This now seems like a meager amount considering the magnitude of what was to be undertaken. There is no accounting of what was spent, but Evermann did document very well the streams he seined, the fish he found, and with whom he traveled. He did not waste time, as shown in his 1894 report upon the Fishes of the Missouri River Basin: "Oct. 6. Began work at Deadwood, S. Dak. Oct. 7. Drove to Spearfish and examined Spearfish Creek and numerous springs in vicinity."

Winter soon set in. The fisheries fieldwork ceased in early November 1892 and did not resume until June 1893. Over the next two months, Evermann and his crew examined not only potential hatchery sites, "but included an examination and study of the physical and biological features of the waters, with especial reference to the species of fish and other animal life they already contain, and their suitability for stocking with other species of food-fishes not indigenous to them."

The waters of the Black Hills were thoroughly vetted by the scientist, and it was Spearfish to which Evermann returned. He told Congress why:

> Spearfish Creek—This is by far the most picturesque of all the streams of the Black Hills seen by us. We examined Spearfish Creek at the town of Spearfish where it was 30 feet wide, 1 foot or more deep, and with a swift current. The bottom was gravelly and there was considerable vegetation along the banks. From it we took brook trout (planted), Jordan's sucker, and western dace. The stream is a fine one, indeed. The bulk of its water comes from the hills, but even at Spearfish there are some fine springs. If fish-cultural work should ever be undertaken at any place in the Black Hills, the most satisfactory natural conditions could probably be found here.

And, so it would come to pass. Spearfish National Fish Hatchery, situated about a mile from the bustling downtown, was operational by July 1899. It began with 17 ponds and a handsome hatching house designed by US Fish Commission architect and engineer Hector von Bayer. It was neatly tucked in narrow Ames Canyon, bracketed by limestone outcrops the color of a wet mule. The hatching house sat in a commanding position above the creek. DeWitt Clinton Booth, a New York native likely named for his home state's former governor and US senator, took charge of the new federal fisheries facility. Except for a brief hiatus in Homer, Minnesota, where the US Fish Commission built its boats, Booth worked at Spearfish for the rest of his career. He lived out all of his days in Spearfish as a fixture in the community. A comfortable and attractive house

built on station in 1905 and 1906 was undoubtedly an upgrade from living in the upstairs of the hatching house, especially when Booth married Ruby Hine, a music teacher at the nearby Normal School (the present-day Black Hills State University).

Spearfish National Fish Hatchery produced trout. Booth and crew, sometimes along with their families, made arduous annual forays into Yellowstone National Park to collect the spawn of "black-spotted trout," as cutthroat trout were called at the time. The fertilized eggs were returned to Spearfish for raising and stocking in the Black Hills streams. The crew made these trips until 1911, by rail and by wagon, hauling most of their physical needs with them, including boats and nets. Other species of trout would eventually come from the Spearfish hatchery: brook, brown, rainbow, and lake trout. Most anglers will agree trout live in pretty places; the Black Hills are no exception, and the trout are there because of the work of the hatchery.

The quality of the spring waters that Evermann found did not last. The water source failed, and the springs dried up around 1940, so the US Fish and Wildlife Service looked for reliable water nearby and built Unit 2, the McNenny station, a few miles from Spearfish. In a move that one assumes Evermann would approve of, Spearfish National Fish Hatchery became a training center for work with fish diets and nutrition, adding a genetics research laboratory to the mix along Sand Creek in Wyoming, while the new McNenny hatchery produced the bulk of the trout. Together, the three stations made up the Spearfish Fisheries Complex.

Spearfish National Fish Hatchery went through another permutation when something else dried up: funding. In the 1980s, the US Fish and Wildlife Service divested of a number of facilities in the National Fish Hatchery System across the country. McNenny was turned over to the South Dakota Department of Game, Fish, and Parks. The City of Spearfish took over operations of the Spearfish facility and changed its name to honor the hatchery's first superintendent. Then, in 1989, the old facility took a new turn to become an archive, operated again by the US Fish and Wildlife Service, for all things related to fisheries conservation.

Today, on the grounds of the D.C. Booth Historic National Fish Hatchery and Archives, the still picturesque Spearfish Creek travels downhill over rounded stones. Its silver music fades as one approaches a preserved boat, *US Fisheries 39*, a craft that operated on Yellowstone Lake in the 1920s. A railcar resting near the boat is similar to what the men of the US Fish Commission used to carry fish overland before the advent of highways and tank trucks. Inside von Bayer's hatching house, still in its commanding position, a museum with old tools and artwork and photographs tells the fisheries' conservation story. The old superintendent's residence up the hill, now commonly called the Booth House, is as pleasant to look at as it is entertaining to tour. Appointed with period furniture and accessories—some of it original—the residence helps visitors learn how the Booth family (and several other families) lived.

Perhaps the greatest treasures are those most protected. They are stored in carefully selected materials in the Collection Management Facility in climate-controlled storage and cared for by specialists. Meticulous records enable staff to quickly retrieve materials for researchers or for exhibit. Some 175,000 items related to fisheries conservation are preserved here, including most of the photographs in this book. Some of the most impressive items include 100-year-old serving dishes emblazoned with the agency's logo used by fishery workers. Scads of game warden and railcar worker badges are laid out in a tray as if in formation. Wool flags that adorned ship masts at sea or on big rivers are spread without wrinkles. Reports and ledgers—documents written in sinuous longhand—tell in great detail what fish went where dating to the 1880s. These items have come from across the country and are of great use to researchers of history and conservation.

A 1919 photograph of a now-extinct yellowfin cutthroat trout from Colorado is particularly moving. It may be the only known image of the fish. It seems appropriate to have a home here, almost in a circularity of experience. The fish was described for science by Barton Warren Evermann the year before he visited Spearfish. It now resides here, if only on printed matter, in a place he deemed quite suitable for trout.

—Craig Springer

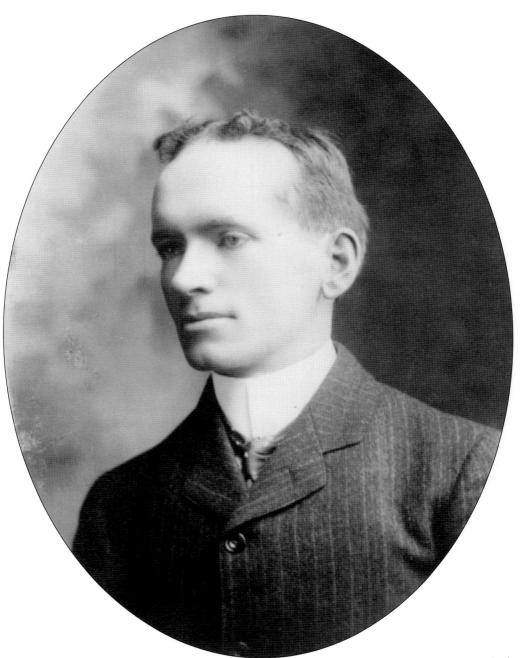

DeWitt Clinton Booth, who insisted on being called "D.C.," started his fisheries career with the distinction of being the first federal Civil Service employee in the US Fish Commission. He obtained knowledge and experience in the commercial fisheries of the Great Lakes, marine fisheries of the Atlantic Coast, and cultured fisheries of the Rocky Mountains. He was promoted in 1899 to head the new fish cultural station being built in Spearfish. As the youngest superintendent in the US Fish Commission, he went on to establish himself as a well-respected authority and pioneer in the field of fish culture.

One

In the Beginning

Spearfish, South Dakota, had a few things going for it late in the 19th century that made it an appropriate place for a fish hatchery. Spring water poured from the bottom of Ames Canyon a mere mile from downtown. A rail line, a necessity for moving fish to stocking sites, was nearby. And, perhaps equally important was the existence of the political will needed to have a federal fishery facility in South Dakota. That was manifest in a bill introduced in 1890 by US senator Richard F. Pettigrew from South Dakota. It authorized the US Fish Commission to seek out a site for such a place in the Dakotas, Montana, Nebraska, or Wyoming. Spearfish rose to the top. In June 1896, Congress established the US Fish Commission's Spearfish Fish Cultural Station in the Black Hills of South Dakota.

The US Fish Commission purchased the hatchery site on June 10, 1898, from John S. Johnston, one of the first Spearfish homesteaders. J.H. Russell Construction Company of Spearfish constructed the hatchery building and icehouse for $5,995. By July 1, 1899, the contractor had nearly completed his work, and 17 fishponds were ready to receive fish. The US Fish Commission appointed DeWitt Clinton Booth, a seasoned fish culturist who had worked at federal stations at Cape Vincent, New York; Woods Hole, Massachusetts; and Leadville, Colorado, to head the hatchery, making him the youngest superintendent in the commission.

Shortly after the station was completed, and while it was still lacking hatching trays and other equipment, the assistant fish commissioner in Washington, DC, sent a telegram asking how soon the station would be ready to receive a shipment of trout eggs. Booth wired that the hatchery would be ready at any time. The hatchery crew set to work making egg trays, building supply troughs, installing faucets, and turning on the spring water in time for the first shipment. By July 29, 1899, one hundred thousand trout eggs were incubating, destined to populate Black Hills streams.

In 1903, the US Fish Commission became the US Bureau of Fisheries, the predecessor of today's US Fish and Wildlife Service, under the Department of Commerce and Labor. Over the next decade, the bureau's Spearfish station stocked almost 20 million rainbow trout, brown trout, brook trout, cutthroat trout, lake trout, Arctic grayling, and Atlantic salmon in South Dakota and the surrounding states. Spearfish National Fish Hatchery went on to have a profound influence on fisheries in the western United States.

—Carlos R. Martinez

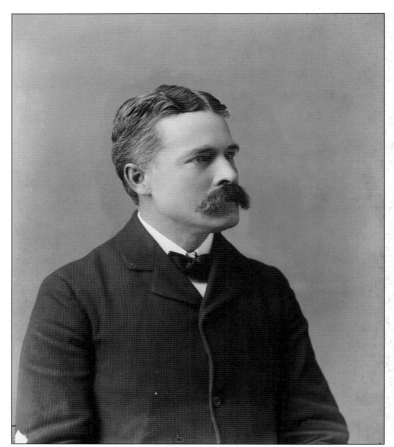

Barton Warren Evermann, employed by the US Fish Commission, surveyed Black Hills fisheries in 1892. Spearfish Creek, Ames Canyon springs, and the nearby railroad convinced him that the site was suitable for a fish hatchery. Construction of Spearfish National Fish Hatchery commenced in 1898, and fish production started the next year. Evermann located several hatchery sites for the US Fish Commission and described scores of new fish species. Mount Evermann, on Mexico's Socorro Island, and many fish are named in his honor. (Library of Congress.)

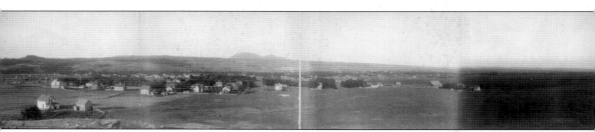

Spearfish serviced an agricultural community in its early years. The town is a great deal larger today, and its economy has decidedly shifted toward tourism. This image, taken in 1902 from the aptly named Lookout Mountain, captures a time when Spearfish National Fish Hatchery was three years into producing trout for Black Hills streams. The hatchery is in the trees on the left side of this panorama that marks the course of Spearfish Creek. (Library of Congress.)

Spearfish Creek glides, pours, batters, and falls down Spearfish Canyon, a 15-mile-long natural wonder that impressed the likes of US Fish Commission scientist Barton Warren Evermann and famed architect Frank Lloyd Wright. Spearfish Falls, captured in this 1889 image, drew tourists when the railroad was literally laid over the top of the crest of the cataract. Prior to artificial stocking, the creek was naturally devoid of trout. (Library of Congress.)

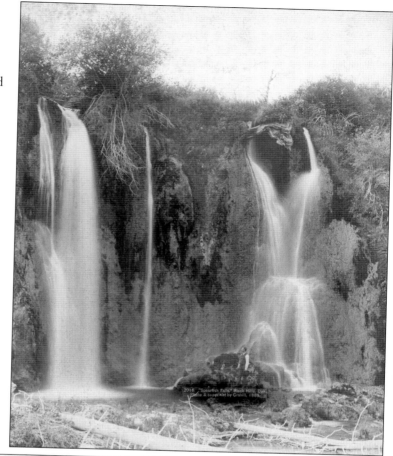

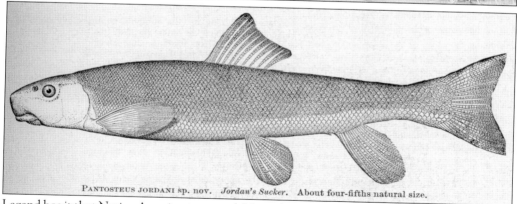

PANTOSTEUS JORDANI sp. nov. *Jordan's Sucker.* About four-fifths natural size.

Legend has it that Native Americans speared fish in the waters of the Black Hills, hence the name Spearfish. Early native anglers would have harvested chubs and suckers. Jordan's sucker (seen here), now known as the mountain sucker (*Catostomus platyrhynchus*), was found in abundance by Barton Evermann during his early investigations of the Black Hills. The first trout introduced to the area was the brook trout, obtained by private citizens from Leadville, Colorado. Trout fishing in the Black Hills would eventually attract ardent anglers and US presidents alike. (Freshwater and Marine Image Bank.)

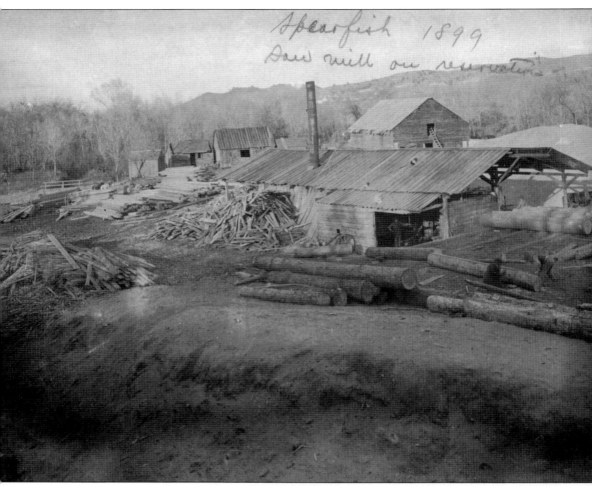

The hatchery site, located at the lower end of Ames Canyon, previously housed a sawmill that operated on the grounds with adjoining cook shacks, bunkhouses, stables, a blacksmith shop, and piles of lumber, refuse, and sawdust. A document from the D.C. Booth archive indicates that the oldest building in the immediate vicinity of this property was a log structure believed to have been built around 1877 and "put here by the first whites, and used as a kind of fort by them when attacked by the Indians."

At right, Deadwood Central Railroad engineers pause for the camera while cutting sloped paths through the rocky Black Hills that would convey metal ore, people, and fish. Before the advent of paved highways and tank trucks, railroads were essential in moving hatchery fish and eggs. The DCR merged in 1904 with the Grand Island and Wyoming Central Railroad (in 1893, the GI&WC was the first to operate through Spearfish Canyon), the Black Hills and Fort Pierre Railroad, and the Burlington and Missouri River Railroad to become part of the Chicago, Burlington and Quincy Railroad. All four were in various locations in the hills. Below is an 1890 image of the BH&FP running through Elk Canyon. Prone to flooding, the Spearfish Canyon section of the line was finally abandoned in 1934. (Library of Congress.)

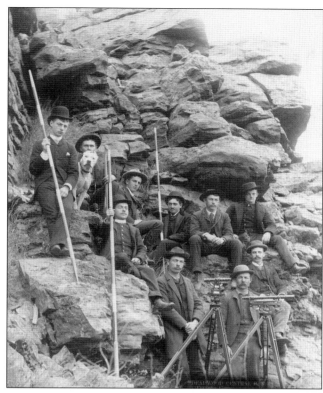

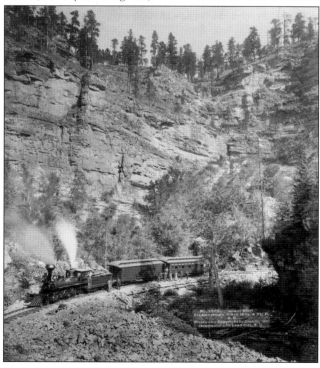

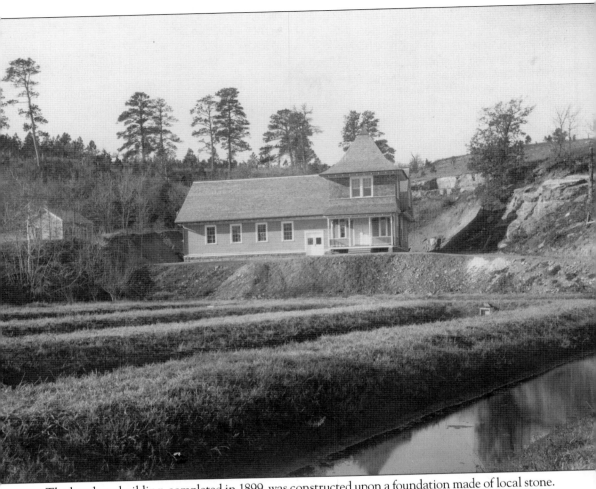

The hatchery building, completed in 1899, was constructed upon a foundation made of local stone. The frame structure was 66 feet long by 32 feet wide and was covered with red wood shingles. An attached transept and tower, 17 feet by 17 feet, was capped with rolled copper soldered together and secured with copper nails.

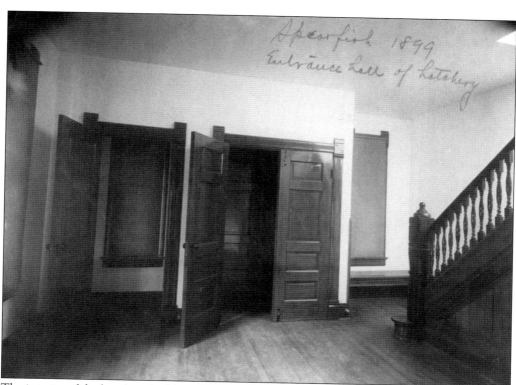

The interior of the hatchery building contained a hatching room, office, reception hall, and boiler room on the first floor. The second floor contained two bedrooms and closets. The interiors were lathed with three coats of plaster. Mortar for the first and second coats was specified to be made with the best fresh-burnt lump lime and fresh-picked cattle hair. The exterior was painted a natural light straw color with white trim.

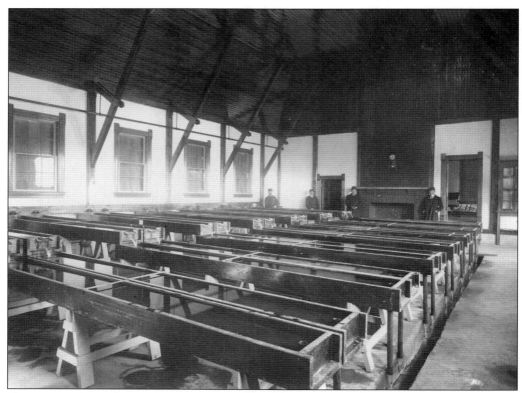

Designed to handle two million trout eggs, the hatching room contained 48 hatching troughs fitted with trays and brass valves. The tongue-and-groove ceiling and exposed eight-inch trusses provide architecturally pleasant aesthetics. Unidentified workers stand in the back, including two men in uniform on the left. Perhaps D.C. Booth is among them.

The boiler utilized a 24-inch coal chute. Heat was supplemented by two fireplaces: one in the hatching room and the other in the office.

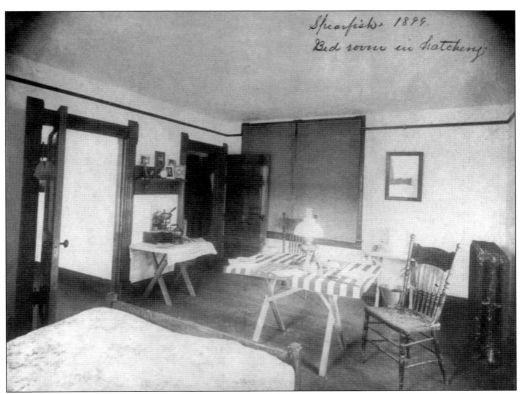

The first employee housing at the Spearfish hatchery is shown in a November 17, 1899, photograph. This room, located on the second floor of the hatchery building, contains everything a person could need: a bed, a table, a hot plate, a washstand, a mirror, a closet, and essential furniture. One of 12 photographs of the newly constructed hatchery, it was taken to send to the headquarters of the US Fish Commission in Washington, DC.

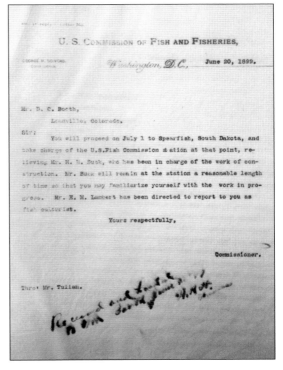

This 1899 letter from the headquarters of the US Fish Commission in Washington, DC, documents a promotion for DeWitt Clinton Booth. It informs him that he will leave the Leadville Fish Culture Station in Colorado and proceed to Spearfish, South Dakota, to serve as superintendent; Booth would keep this position for more than three decades.

The hatchery building and ponds were supplied by pure spring water that rose on the hatchery grounds. The springs were located at a sufficient elevation so that simply by the force of gravity water poured downhill into the hatchery building and its troughs and into the various ponds; the water eventually poured into Spearfish Creek. The ponds were typically and reliably in the upper 40-degree-Fahrenheit range, which is very favorable for incubating trout eggs. Trout have a natural affinity for cold water.

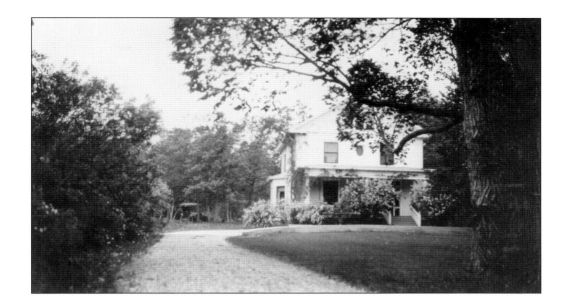

The superintendent's residence was constructed in 1905. The Neocolonial Revival home consisted of a two-story wood frame dwelling with a masonry foundation and basement made of rusticated sandstone. The home features two expansive porches with classical columns, oval windows to light closets, a bay window, and a rear balcony. The interior had eight rooms, electricity, indoor plumbing, a bathroom with hot water, and central heating. This structure provided modern, comfortable living quarters for DeWitt Clinton Booth and his family until his retirement in 1933. Today, the structure is commonly called the "Booth House."

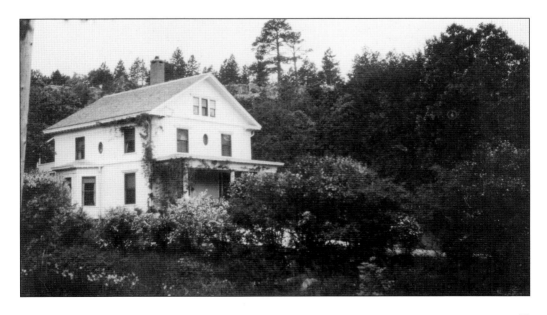

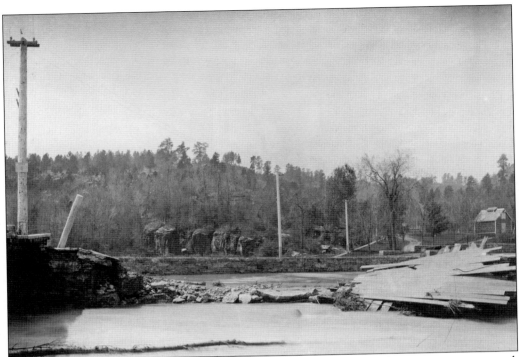

In July 1899, shortly after the first eggs were placed in the hatchery troughs, a rainstorm occurred, washing down tons of refuse. The debris completely filled the spring reservoir supplying the hatchery building and deposited several inches of sediment in all the ponds and hatching troughs. The station went on to endure a number of high-water events throughout the years. A large amount of damage is apparent in this photograph taken shortly after a deluge in 1909.

This rare photograph illustrates the landscape in the 1890s prior to the construction of Pond 1. Eventually, this would be the site of the viewing windows and the Pond Shop gift store built in 1994.

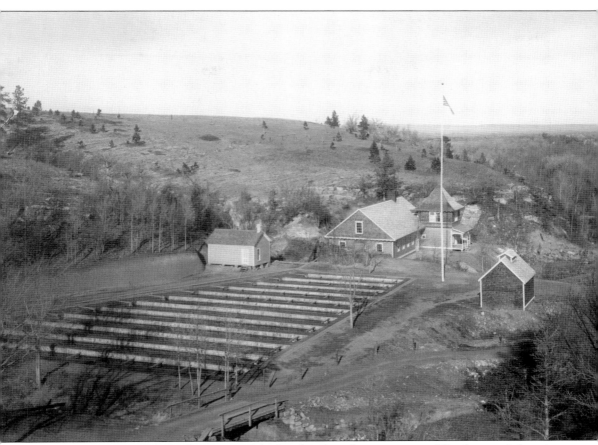

This 1899 photograph displays some of the hatchery's earliest structures. The first workshop is left of the newly constructed hatchery building in the center. Hatcheries require refrigeration, which was provided by an icehouse (far right) with a capacity to hold 35 tons of ice. The site of the 12 raceways in this image is now the site of the Collection Management Facility and home to the hatchery's administrative offices.

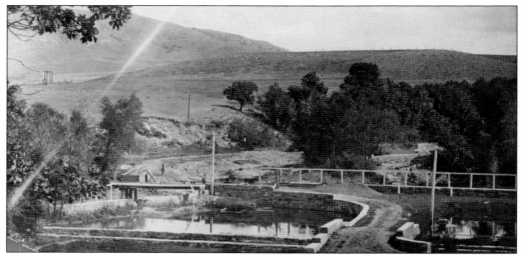

This somewhat rare photograph shows the hatchery grounds as they looked at the start of the 20th century facing east from the historic hatchery building. The image puts into perspective the number of modifications the facility has experienced since its inception. Also of note is that the landscape in the background is void of development.

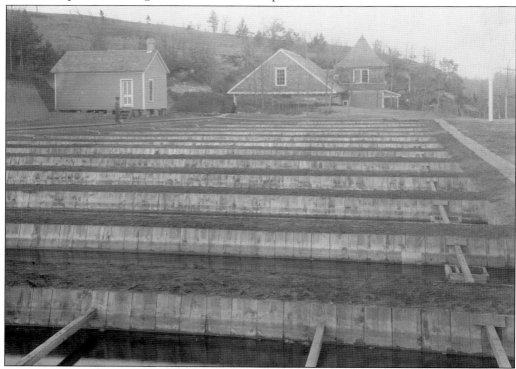

Raceways and ponds were built on the slope south of the hatchery building. Ponds 1 through 8 came first, built in 1899 with native pine on the sides over earthen bottoms (seen here). Ponds 9 to 12 were dug in 1900 and lined with cypress. Ponds 13 to 16 were merely excavated and had earthen bottoms and sides. Limestone walls shored up ponds 18 through 20, and the last of the 24 ponds were built in 1913 with cement and earthen bottoms.

the same with data used by me, and to arrive at a definite conclusion. The Commission bought Johnston's springs & land at Spearfish, and the right of to the above said "Kroll's" springs. Address me, please, at Washington, since I expect to return shortly.

Hoping you well in your elevated atmosphere

I am very truly
H. von Bayer.
Archit. & Engineer.

In this correspondence, Hector von Bayer documents the status of the property that would become the Spearfish National Fish Hatchery. Von Bayer, the US Fish Commission's architect and engineer, was a talented mechanical artist and inventor. He designed the hatchery building at Spearfish, as well as many others like it around the country; his building in Spearfish is the last one that remains fully intact. Von Bayer worked for the US Fish Commission and the Bureau of Fisheries from 1893 to 1920.

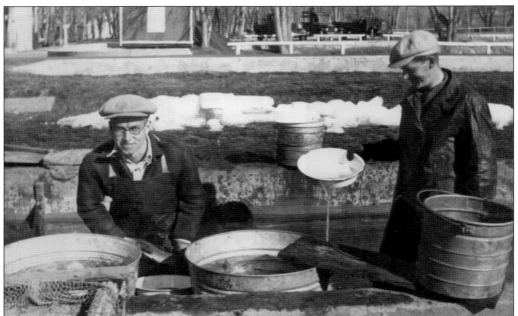

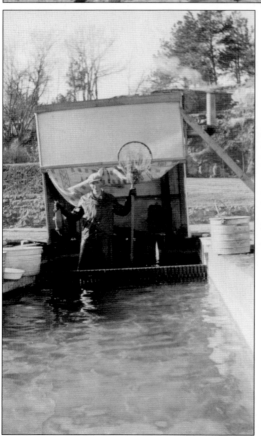

Although it was possible to collect eggs from public waters in the Black Hills, it was cheaper for the Spearfish station to obtain eggs from other federal stations, purchase them from commercial fish culturists, or raise its own mature fish used for breeding purposes (known as broodstock). As early as 1912, the Spearfish National Fish Hatchery used eggs collected on site from its own brook, rainbow, and brown trout broodstock. Working under a tent erected at the end of a raceway, seen at left, provided protection from the elements. In the photograph above, two fish culturists are spawning trout. When female trout are "ripe," they are hand stripped by cradling the fish with the tail lower than the head. The culturist then uses the thumb and forefinger of the free hand to put pressure on the belly and gradually works the pressure towards the tail; this allows the eggs to easily flow into a bowl. The male is then stripped of its milt (the solution containing sperm) in a similar fashion. The eggs and milt are gently stirred with a finger or feather before being placed in egg-hatching jars or trays for incubation.

It is important to accurately estimate egg inventories as they move through the hatchery system. Here, Fish Cultural Station superintendent C.C. Vincent is shown using a Von Bayer V-Trough, an instrument that measures 12 inches in length with a 45-degree bend and a depth of approximately 1.5 inches. Many modern-day culturists still rely on this method, which determines the number of eggs per liquid quart. It was invented by Hector von Bayer, US Bureau of Fisheries architect and engineer, the same individual who designed the Spearfish hatchery building.

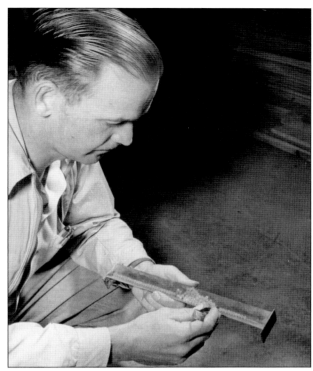

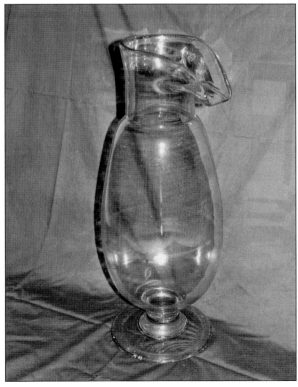

Water temperature determines how fast eggs will hatch. Early fish culturists used hatching trays or beautiful glass egg jars with fresh water circulating through them. After all the eggs hatch, the contents of these incubators are poured onto wire mesh screens suspended in troughs of flowing water. Newly hatched fish, also called sac fry, rely on food stored in pouches, called yolk sacs, on their bellies. After the yolk sac is absorbed, the fish can go on a hand-fed diet.

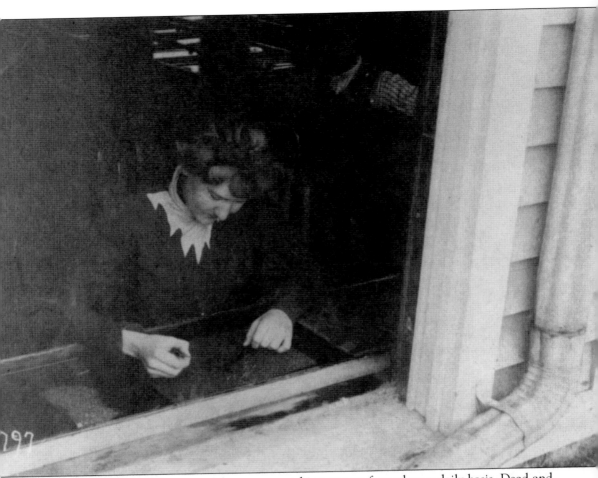

To keep eggs free of disease and fungus, egg picking was performed on a daily basis. Dead and other undesirable eggs were removed with tweezing devices that had small loop rings at the ends that could grasp individual eggs. This photograph shows a woman picking eggs in the light of a window at a hatchery building. It is suspected that the young woman knew the photographer was coming, as she is wearing a lacy white collar more suited to afternoon calls than handling trays of fish eggs. Photographers were a rare sight at the hatchery, and the egg pickers would have wanted to look their best.

During the early days, one of the most common items used to feed trout was beef and sheep liver that was chopped or ground to a pulp. Sometimes it was mixed with a mush made of wheat shorts or middling that was boiled into a thick mixture. Fish culturists tried virtually everything imaginable at some point. Some of the most interesting fish foods mentioned in historical documents include elk, horse, maggots, and grated hard-boiled eggs. In 1937, the Spearfish National Fish Hatchery received 7,000 pounds of ground and dried seal carcasses and 2,000 pounds of dried and ground salmon (salvaged from dead spawning salmon), both originating from the Bering Sea. Every hatchery had a shop equipped to produce various concoctions to feed fish. In the image above, apprentice fish culturist Harlan E. Johnson stands in front of the hatchery's feed room. Below, Loyd Justus, also an apprentice fish culturist, stands next to meat-grinding equipment in the feed room.

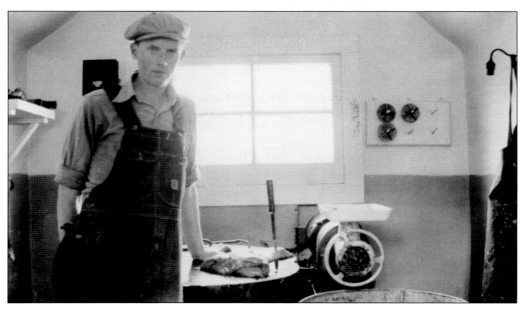

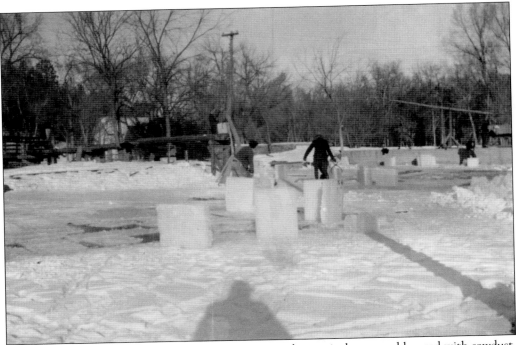

Blocks of ice cut from the ponds in winter were stored in an icehouse and layered with sawdust. The ice, which would last until late summer, was crucial for stocking fish, transporting eggs, and cooling meat products used for fish food. The practicality of electric refrigeration eventually marked the demise of the icehouses. Today, the D.C. Booth Historic National Fish Hatchery commemorates the days of harvesting ice with a replica of an 1899 icehouse.

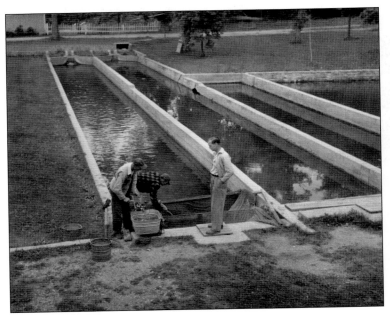

In this image, hatchery workers count and weigh fish as a means of measuring growth rates and estimating the number of fish in the raceways. Biologists can determine how much to feed the fish to help them reach a certain size by a particular date. If the fish are too small, there may be some unhappy customers. Fish that are too large may indicate an unnecessary waste of expenses for fish feed.

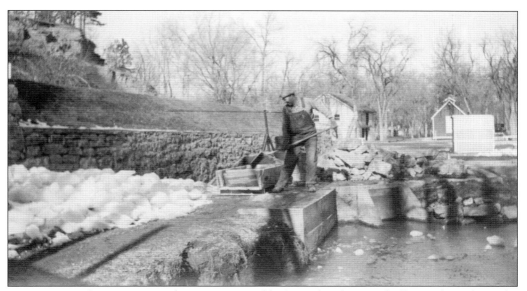

Removing ice from screens and preventing ice blockages has been a challenge throughout the history of the Spearfish National Fish Hatchery.

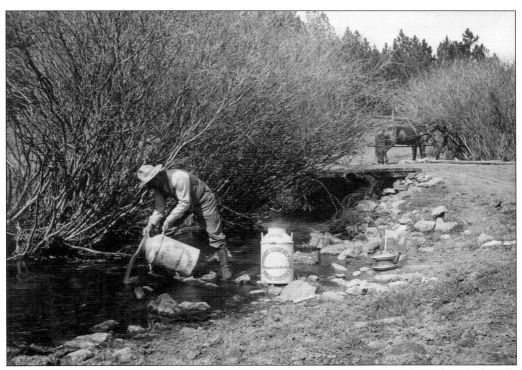

Here, forest ranger Frank T. "Cap" Smith stocks trout into Bear Butte Creek in the Black Hills National Forest. The cans are labeled as belonging to the Spearfish National Fish Hatchery. Milk cans filled with water and fingerling trout traveled by horse, mule, burro, and wagon to eventual stocking sites. Milk cans were commonly used to carry fish from hatcheries in the early 20th century. (Black Hills National Forest.)

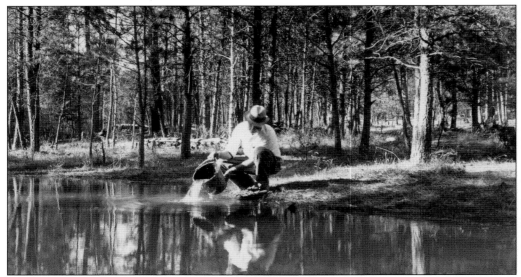

In this image, a South Dakota fish hatchery representative places three- to four-inch trout in a beaver pond on upper Este Creek in the Black Hills. Coincidently, the beavers that built this pond were introduced a few years earlier, in 1932, by forest ranger Manford Hickel.

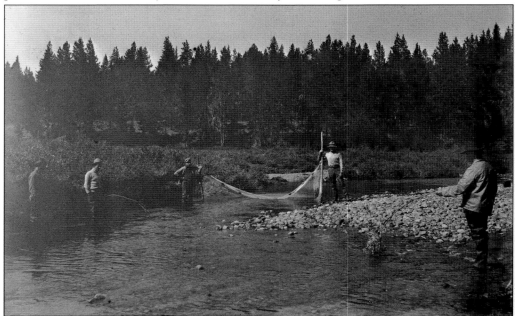

In 1901, D.C. Booth was assigned to assist Yellowstone National Park with fish cultural possibilities. In 1881, superintendent Philetus W. Norris, the second civilian manager of the park, was the first to stock fish in the park by moving native cutthroat trout into barren waters. By 1889, the Army had been called in to restore order in the park, which eliminated poachers. The Army then requested help from the US Fish Commission. Commissioner McDonald visited and initiated stocking in 1889. He also sent noted biologists David Starr Jordan and Barton W. Evermann to investigate. Booth began seasonal work in the park on May 15, 1901, that continued for 10 years. Unidentified workers are seen here seining a stream for spawning trout.

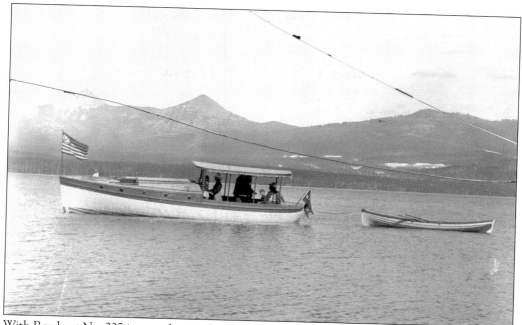

With Rowboat No. 225 in tow, the new launch No. 8 crosses Yellowstone Lake in 1909. The Booth family is on the launch, which has a US Bureau of Fisheries burgee on the rear. The launch was a cabin cruiser type with a seven-foot beam, a 10-horsepower gasoline motor, a stationary roof, drop curtains, and a glass windshield. The steel Mullins rowboat had three pairs of oars and possibly a motor.

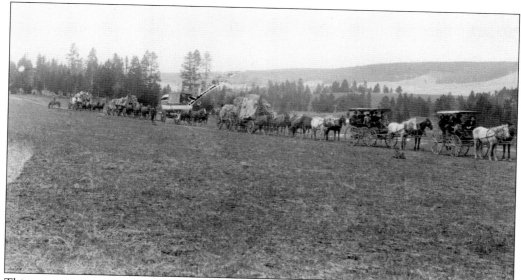

This wagon train with boats is en route to the Yellowstone Lake Hotel area. D.C. Booth ordered the 4,500-pound, 28-foot launch and the 225-pound, 16-foot rowboat from Truscott Boat Manufacturing Company based in Saint Joseph, Michigan. After the boats were unloaded from the park branch line of the Northern Pacific Railway in Gardiner, Montana, Lawrence Link stored them until dirt roads were passable before transporting them into Yellowstone. Ruby and D.C. Booth, with daughter Katharine, travel near the front, while son Edward rides a horse near the rear.

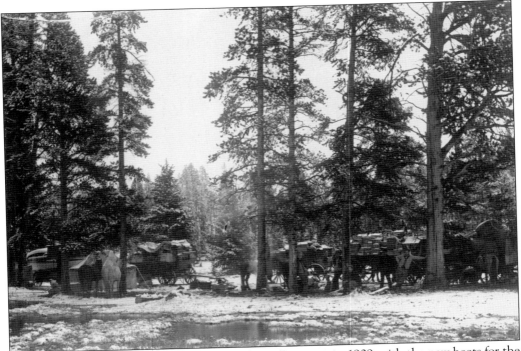

Crews camped for the night among the trees in Yellowstone in 1909, with the new boats for the fisheries program loaded on a wagon. Later that summer, a boathouse was constructed at Lake Village on the shores of Yellowstone Lake. The boathouse, a log building with covered porch, was capable of housing a 28-foot launch and smaller boats, and was adjacent to a creek that would eventually be commonly known as Boat House Creek.

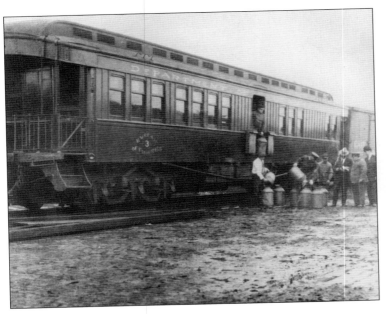

Shad were the first fish to make the trip across the United States, traveling with Seth Green from the East to California in 1871. In 1873, a 27-foot fruit car was fitted by Livingston Stone to transport fish from the East Coast to the West. Sadly, the live cargo was dumped into the Elkhorn River outside of Omaha, Nebraska, when the locomotive collapsed a washed-out trestle. In 1874, a full car of fish successfully made the trip.

The successful transport of a railroad car of live fish across the United States in 1874 proved that the idea was feasible. In 1881, Fish Car No. 1 was purchased by the Fish Commission and converted from a first-class baggage car to move live fish long distances. Additional cars were ordered through the years. The last car, No. 10, was built of steel in 1929. Fish Car No. 3, seen here, was a wooden car.

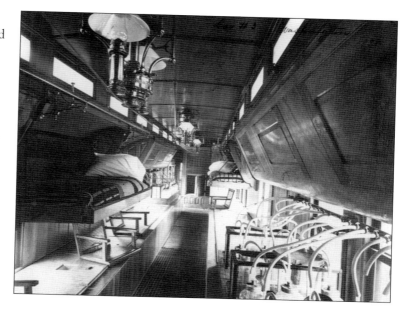

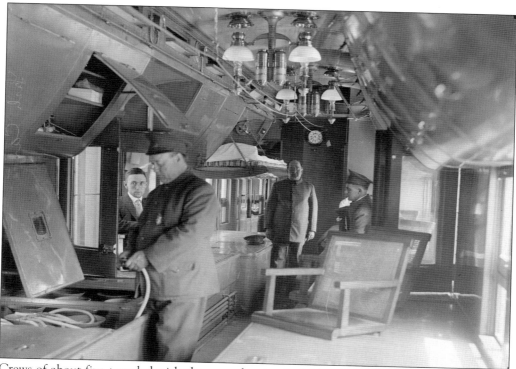

Crews of about five traveled with the cars, sleeping in foldout berths above the tanks and in the captain's office. The captain was responsible for travel and distribution arrangements, as well as notifying recipients to pick up their fish. Each car also had a cook. The messengers took care of the fish and delivered fish on branch lines. Fish Car No. 7, seen here, was a steel car. (Library of Congress.)

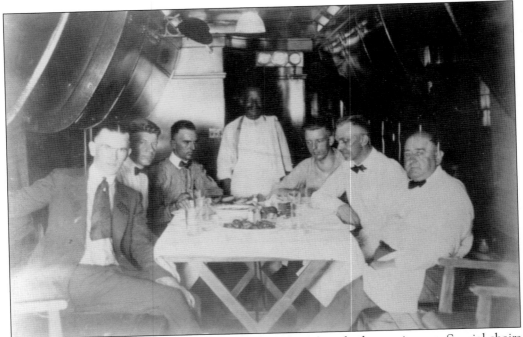

Most of the space in the cars was taken up by tanks of fish and other equipment. Special chairs with no legs were built so that the men could sit on top of the fish tanks. A folding table could be put in the aisle at mealtime. Sturdy ceramic dishes were marked with the logo of the US Bureau of Fisheries, consisting of a red, white, and blue fish flag design. Crews also had uniforms with badges. Thomas H. Copeland (third from the left) was part of the crew of this steel car, Fish Car No. 9. The image was taken around 1925.

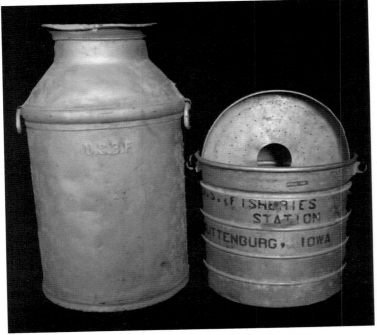

With more efficient fish cars being produced, more efficient equipment was also developed. Lightweight containers called Fearnow pails, invented in the early 1920s by longtime superintendent of the US Bureau of Fisheries Edgar Fearnow, replaced milk cans. The pails weighed less, could carry twice as many fish, took up less space, and had a special compartment that held ice to keep the water cool. Each pail had its own serial number and was assigned to a specific hatchery.

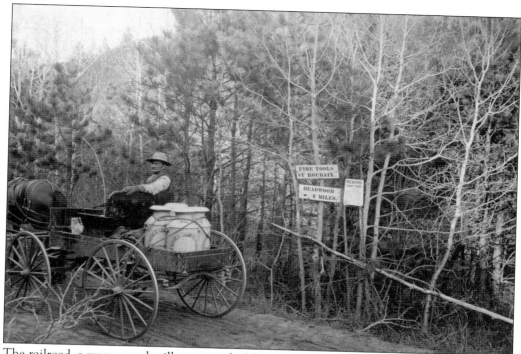

The railroad, a wagon, and milk cans made fish stocking in the Black Hills possible. In this c. 1910 image, forest ranger Frank T. "Cap" Smith is en route to Bear Butte Creek to stock fish. The cans are labeled, "Department of Commerce and Labor. Bureau of Fisheries. Spearfish So. Dakota." Smith arrived in the Black Hills with the gold seekers in 1875, was brevetted a captain in the Spanish-American War, and worked for the US Forest Service from 1902 to 1925. The radius in which fish could be delivered from a hatchery increased with mechanization and improved technology. (Black Hills National Forest.)

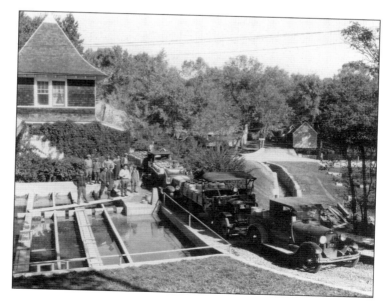

This October 1, 1929, photograph captures 143 cans filled with large fingerling trout loaded on distribution vehicles ready to depart from the Spearfish National Fish Hatchery. In the early 1930s, truck transportation of fish was becoming more common and economical. By 1937, modern trucks began to overtake the fish-car rail fleet, as they were more efficient and less costly. (Fassbender Collection.)

Hatchery workers created early distribution trucks by fitting them with custom tanks constructed of redwood, plywood, galvanized iron, or sheet metal. Stocking functions and objectives remained the same: transport as many fish as possible with minimal loss and in an economical manner. Some trucks were equipped with baffles to minimize water motion and aerators to help maintain dissolved oxygen levels within safe limits.

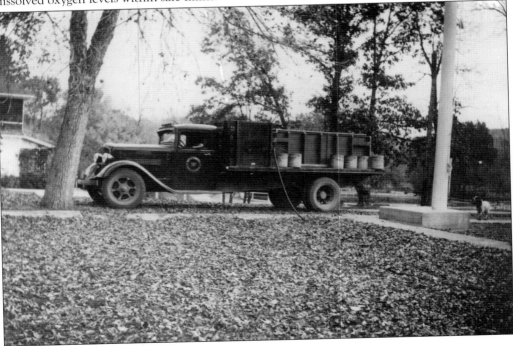

In the early 1930s, improved highways and favorable publicity brought more travelers and tourists to the Black Hills. The area developed a reputation for being a trout-fishing destination. (Black Hills State University.)

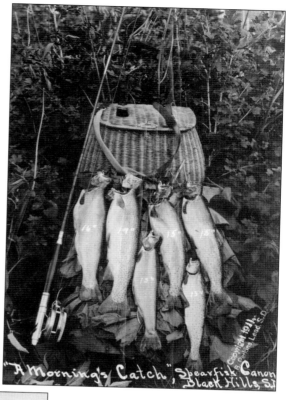

Fishing for food or for sport is steeped in American culture, and it was for both of those purposes that Pres. Ulysses S. Grant and Congress created the US Fish Commission in 1871. The commission established Spearfish National Fish Hatchery toward those ends to promote angling in South Dakota. Anglers buy fishing licenses, which helps pay for fisheries management. Today, fishing fuels a huge economic engine, with the total economic impact of the US Fish and Wildlife Service's national Fish and Aquatic Conservation program amounting to $3.6 billion annually. Conservation stimulates commerce. (South Dakota State Archives.)

In the summer of 1927, Pres. Calvin Coolidge fished in the Black Hills. Coolidge is seen here casting a line with US Secret Service agents in Spearfish Canyon. Secret Service agent Edmund Starling wrote in his autobiography that he arranged for Spearfish National Fish Hatchery to stock the waters ahead of the president's fishing forays, even blocking off sections of stream so that the fish would remain there for the first angler. (US Secret Service.)

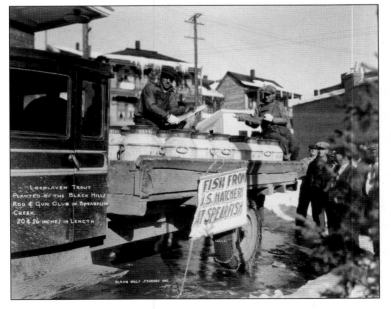

In support of the Bureau of Fisheries, the Black Hills Rod & Gun Club lobbied Congress to appropriate funds to expand the number of nursery ponds and improve the spring water supply at the hatchery. The club is believed to have stocked waters throughout the Black Hills with trout from the Spearfish National Fish Hatchery from the mid-1930s through 1940. The task was then turned over to the State of South Dakota.

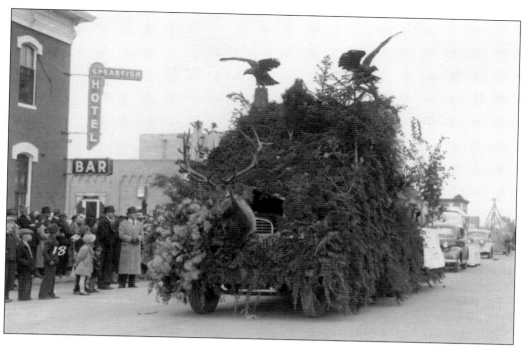

With the hatchery located near the town of Spearfish, it was easy for hatchery staff to be involved in community events. In 1937, the US Bureau of Fisheries participated in the Swarm Days parade with a unique float that promoted fishing, camping, and hunting. The float proudly displayed a campsite and mounted eagles, elk, mule deer, and pronghorn.

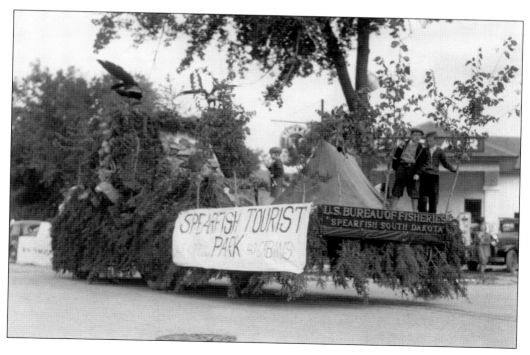

The Izaak Walton League of America is one of the nation's oldest conservation organizations and has a powerful grassroots network of more than 250 local chapters nationwide. Established in 1922, it was originally founded by a group of sportsmen who wished to protect fishing opportunities for future generations. From June 21–23 in 1937, the league hosted a national convention in the Black Hills. Spearfish National Fish Hatchery served as the official location for a number of fly- and bait-casting events. The Weber Lifelike Fly Co. sent $150 worth of flies to display, along with some metal fish meant to represent trout found in the Black Hills. The exhibit pictured at left is in protective custody of the D.C. Booth archive. The whereabouts of the display below are unknown.

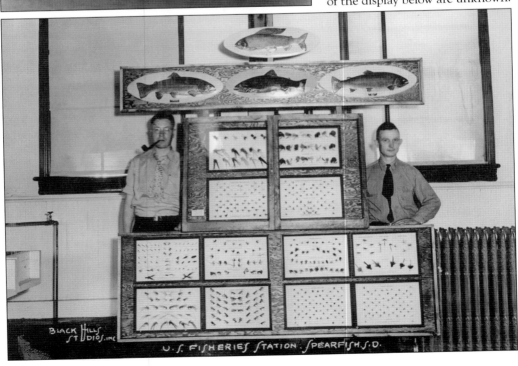

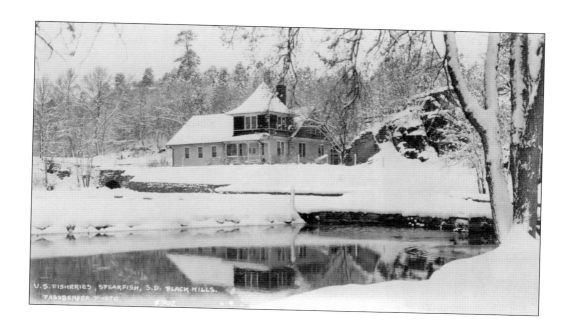

Even in its earliest days, the hatchery was a popular spot for photographers. German immigrant and notable Black Hills photographer Josef Fassbender frequented the facility, finding a picturesque winter day on which to take these photographs in 1927.

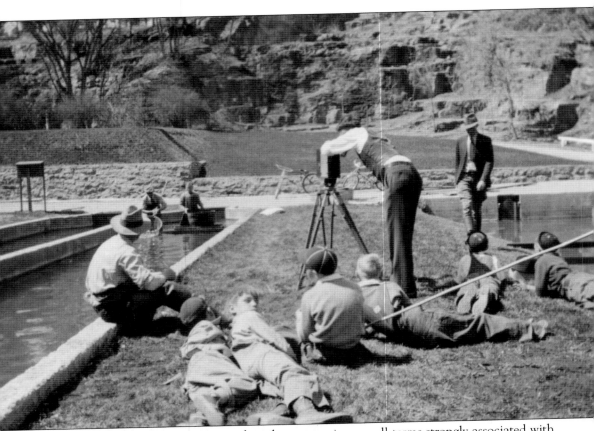

Visitor services, youth education, and outdoor recreation are all terms strongly associated with the D.C. Booth Historic National Fish Hatchery. The hatchery had been a popular venue for the public since its establishment in 1899. Here, a number of children watch the filming of fish culture activities taking place in a nearby raceway.

On November 1, 1933, after 40 years of government service, DeWitt Clinton Booth retired. He chose to live his life out in a cabin built adjacent to the station he directed for over 30 years. Booth turned the Spearfish operation into a prominent center for federal fisheries conservation. Although considered stern and stubborn, Booth was still a well-respected leader. In 1986, the Fish Culture Section of the American Fisheries Society enshrined DeWitt Clinton Booth into the National Fish Culture Hall of Fame.

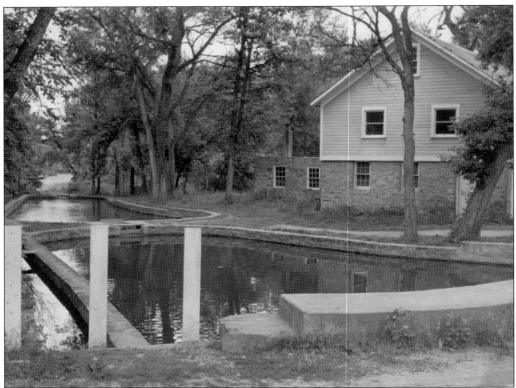

In the above image, Ponds 4 and 5 stand in the foreground of the barn, which was demolished in the late 1950s and replaced in the 1960s with the four-stall garage that stands on the site today. An icehouse, which was adjacent to Pond 3 (pictured below) across from the barn, originally stood where the icehouse replica is now displayed at the D.C. Booth facility. It was most likely disposed of when the station obtained a walk-in freezer. Pond 3 has some earthen sides in this shot, but it would eventually have stone walls throughout with built-in planters.

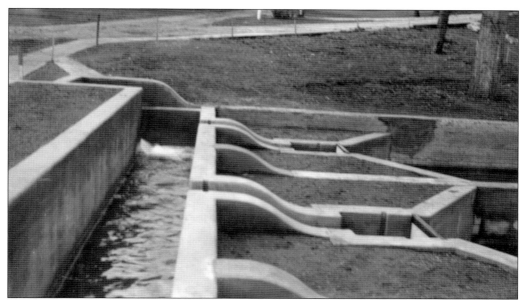

During the 1930s, hatchery workers attempted to use all available water. Water from five different sources was collected and distributed to the nursery pond and raceway system. The replica raceways on display at the D.C. Booth Historic National Fish Hatchery today mimic the old system seen here.

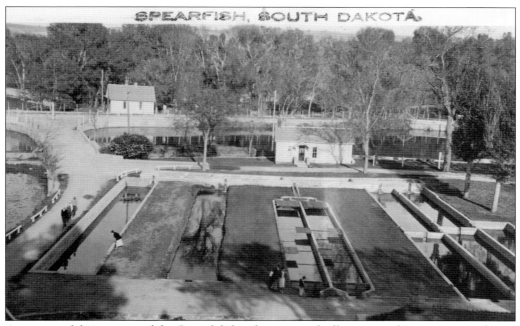

An eastward-facing view of the Spearfish hatchery grounds illuminates the raceways, with one still in its early earthen form. Employee housing is seen in the center of the image. A number of visitors are leisurely roaming the facility, presumably to get a glimpse of some trout.

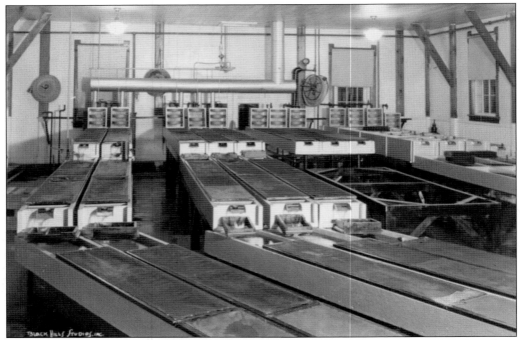

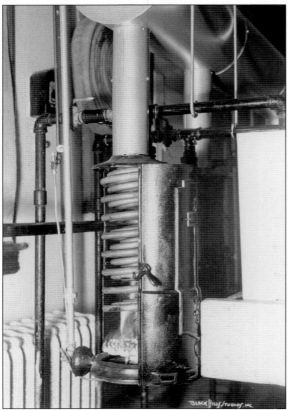

In the 1930s, the springs began to dry, and it became necessary to use water from Spearfish Creek. During the months from November to March, the water can dip to freezing temperatures, resulting in very unsatisfactory trout egg incubation. In 1937, hatchery foreman Theodore Kibbe tested a water-heating system (above), which he devised in the hatchery building, on brook trout and brown trout eggs. Using a natural gas–fired double-coil heater (left), which was metered and controlled by a thermostat, he obtained desirable water temperatures at a reasonable cost. Successful trials resulted in a number of other federal and state hatcheries with freezing water issues following his lead.

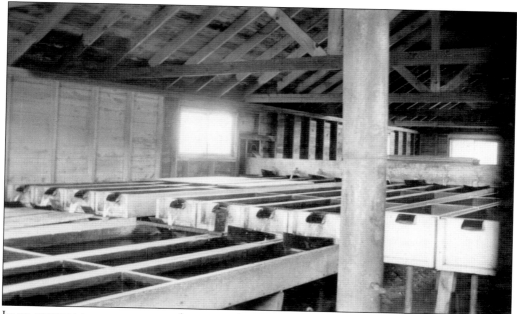

In an attempt to counter water shortages, the Spearfish National Fish Hatchery established a substation at the "McGuigan place" in 1932. Although it played an important role in the winter care of eggs, little else is known of this short-lived facility. The water source failed, and the structure was torn down in 1936. This image is believed to show the inside of the McGuigan substation.

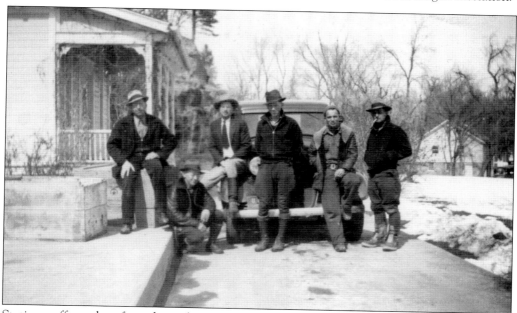

Station staff members from the mid-1930s pose near the hatchery building porch. They are, from left to right, William Dunn, William Bowling, foreman Charles Fuqua, apprentice fish culturist Harlan E. Johnson, apprentice fish culturist Ralph W. Young, and fish culturist Leonard Hunt. Bowling, and presumably Dunn, worked in the fish-car service and periodically performed winter details at Spearfish.

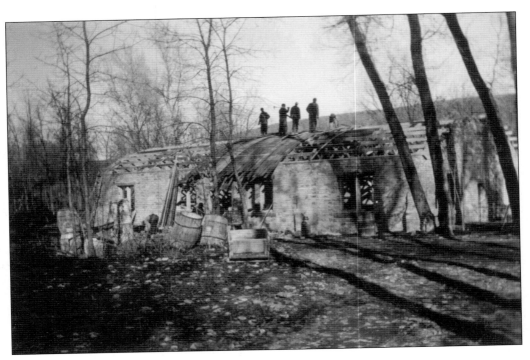

In an attempt to create a better spring egg-hatching facility, the "auxiliary hatchery" was constructed by the Works Progress Administration (WPA). In the above image, laborers are close to completing the roof. The structure, which was completed in early 1937 and is pictured below, was wired for electricity and gas.

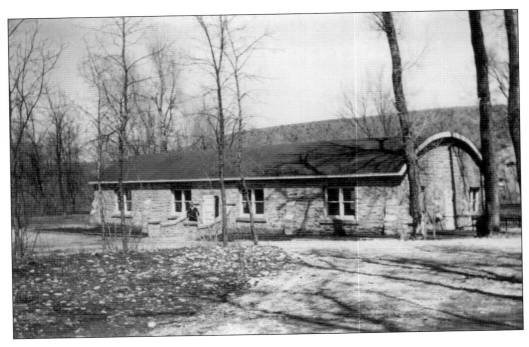

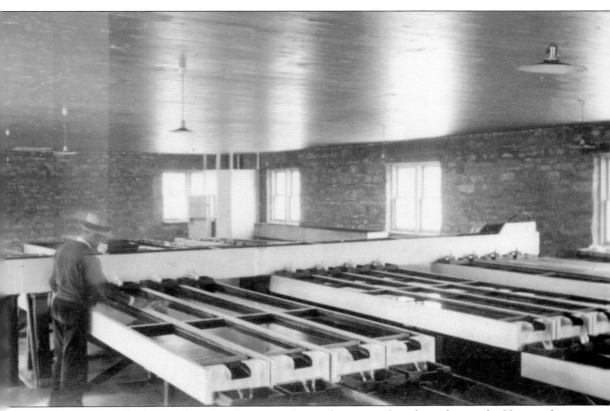

Clean water for the auxiliary hatchery was obtained via a pipeline from the nearby Homestake Mining Company's hydroelectric plant. Metal troughs were shipped from the Fairport Fish Cultural Station in Iowa. Unfortunately, the auxiliary hatchery structure was only used for five years due to water complications. The Snappers, a local rifle club, utilized the structure as their clubhouse until 1981. Today, the building still stands. Known as the Snappers Club, the City of Spearfish rents it out for receptions and community events.

The US Bureau of Fisheries received a fair amount labor and project completion from the WPA relief program. Many of the structures built for the Spearfish hatchery still stand today. These include a residence seen above, the auxiliary hatchery (known today as the Snappers Club pavilion), and two stone garages, one of which is illustrated below.

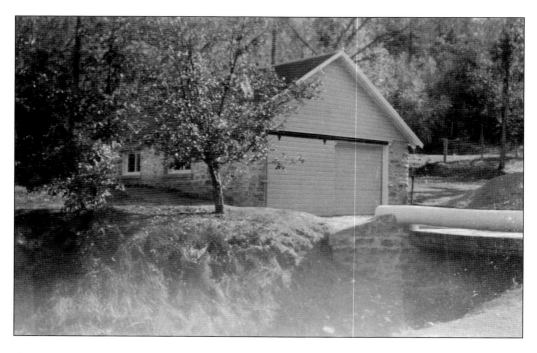

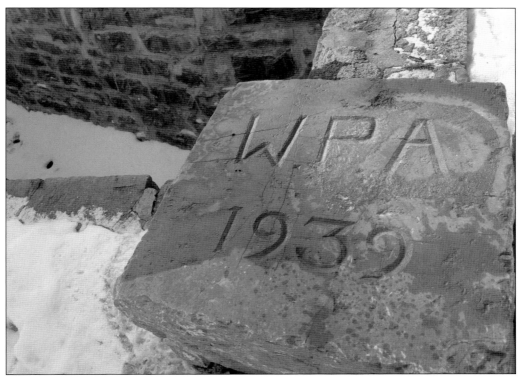

WPA laborers constructed a number of ponds, drainage channels, and retaining walls made of native stone. These projects helped meet the demand for increased fish production. The plan pictured at right illustrates improvements made to a fish production pond in the late 1930s; the modifications are visible on site today.

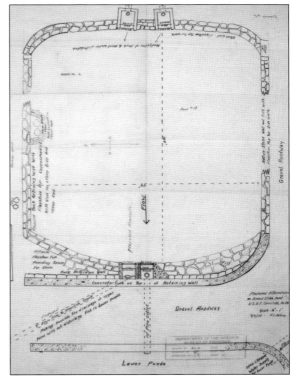

In 1941, the Spearfish National Fish Hatchery was selected by the Washington DC headquarters as one of two new fish biology labs meant to study pollution and water quality for hatcheries. Spearfish was selected because of what was deemed ideal water conditions, and it had the only temperature-control system, which was developed by T.S. Kibbe and perfected under foreman John Harrington. The lab was constructed in the original hatchery building, because by then all egg hatching was performed in the auxiliary hatchery building constructed by the WPA.

Two

AT HOME ON THE HATCHERY

Many people have called the hatchery home, from single men to large families. Housing on the grounds allowed staff to be around to keep an eye on the fish, making sure they were safe with flowing water. Modern hatcheries include alarm systems that alert staff to water or power issues. The quarters at the Spearfish hatchery varied through the years and included rooms above the hatchery building, a small house by Pond 1, a house constructed by the Works Progress Administration, the Forest Service house, and the superintendent's residence. Other staff members lived in the surrounding area. Family members frequently helped out, usually without being paid, by feeding fish, going on stocking trips, picking eggs, and more. Children enjoyed playing on the 10-acre hatchery grounds. Some children swam in the fishponds, whether they were allowed to or not. Hatchery staff and families were also part of the Spearfish community, joining organizations, going to school, working, and attending churches.

The first employee on site was W.P. Sauerhoff, who was sent to oversee the start of construction late in 1898. H.H. Buck soon replaced him as the construction superintendent. These men probably lived in Spearfish, with D.C. Booth becoming the first to occupy a room above the hatchery building when he took over on July 10, 1899. Booth probably had little time for interior decorating, as the first eggs arrived on July 29, 1899. He was also busy getting the hatchery up and running, purchasing and constructing equipment, implementing the latest in hatchery procedures, keeping records, and managing the budget.

Ruby Hine also arrived in Spearfish in 1899 as a music teacher at the Spearfish Normal School (now Black Hills State University). She married D.C. Booth in 1901 and moved into the quarters above the hatchery. By this point, both upstairs rooms were probably available for the family's use. The reception room downstairs was added to these quarters by 1907. The Booth children, Edward and Katharine, were born upstairs in the hatchery in 1902 and 1904, respectively. The superintendent's residence, now called the Booth House, was built in 1905–1906. Hatchery staff moved furniture into the house in early 1906. Students could be educated at the Spearfish Normal School from the primary grades through two years of college.

As government employees, residents of the hatchery typically brought their own furnishings and took them when they left. In later years, they paid rent. Upkeep on the quarters was frequently done by hatchery staff. The superintendent's residence was usually occupied by the highest-ranking employee, while other staff lived in smaller houses.

—Randi Sue Smith

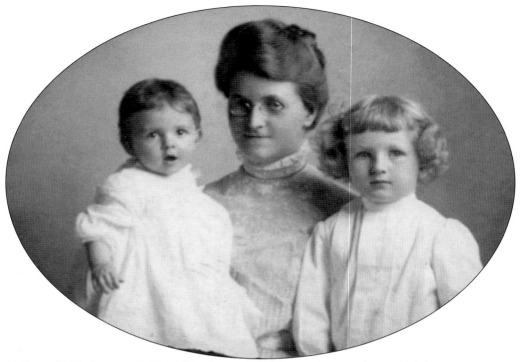

In this c. 1905 photograph, Ruby Booth poses with her children, Edward (right) and Katharine.

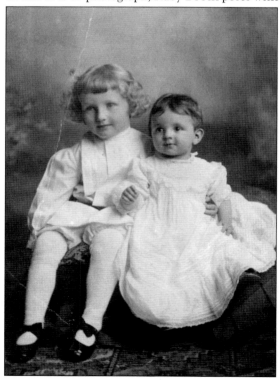

In this c. 1905 photograph, the eldest sibling, Edward Booth, helps support Katharine.

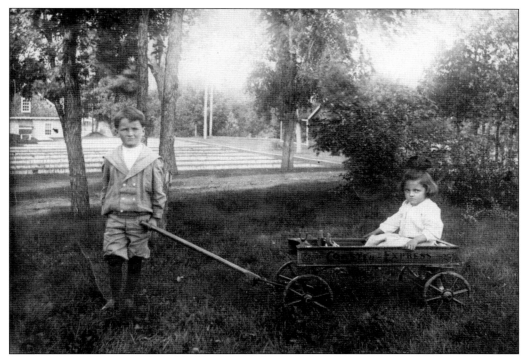

Dressed in a sailor suit, Edward holds the handle of a wooden Coaster Express wagon carrying his sister. In the background, the icehouse is on the right, and the board-lined raceways and hatchery building are on the left.

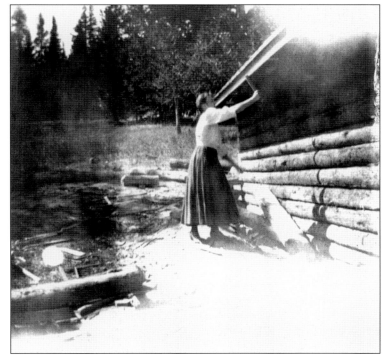

The entire Booth family went on at least one trip to Yellowstone National Park when D.C. Booth was managing the fisheries work in the park. Crews lived in tents until structures could be built. Ruby Booth (seen here) helped out, including picking eggs.

Ruby Booth pauses for refreshment, perhaps an early morning breakfast, while enjoying the outdoors in Yellowstone National Park. Setting aside land for preservation and public enjoyment was a concept that originated in the United States.

Katharine Booth is dressed for a cool day outside in Yellowstone.

Edward and Katharine Booth hold hands for safety as they walk down the dock towards the fisheries boats and the gear sitting on the dock.

Edward and Katharine Booth play outside in the patchy snow. Behind them stands the workshop where hatchery workers prepared fish feed.

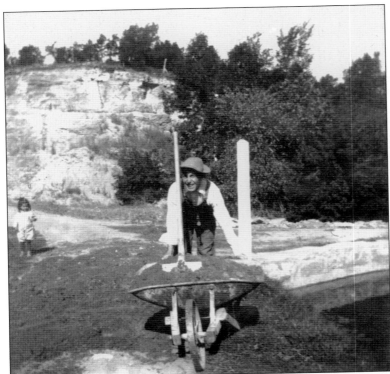

A smiling D.C. Booth, dressed in overalls, pushes a wheelbarrow down by the ponds. Katharine Booth, dressed in a playsuit, is on the left. The road up to the hatchery building curves below the rock face. Stone used for building projects at the hatchery was often quarried on site.

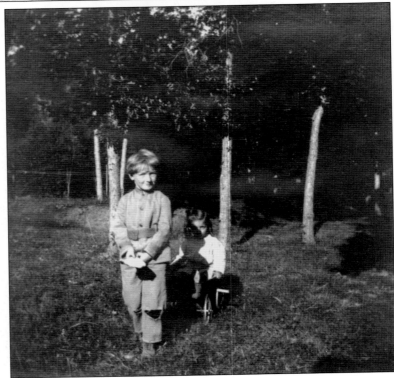

Edward and Katharine Booth play on the hatchery grounds, suitably dressed for the occasion.

Few children can resist a hose with running water, and the Booth children were no exception, as shown in this image from the backyard of the superintendent's residence. One can imagine a parent sneaking around the corner of the house to snap this photograph.

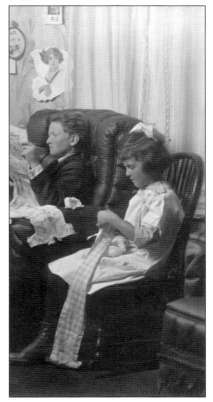

Edward and Katharine Booth pose inside the superintendent's residence for one of two known photographs taken inside the house while the Booths lived there. The children are pursuing typical gender-specific activities for the time.

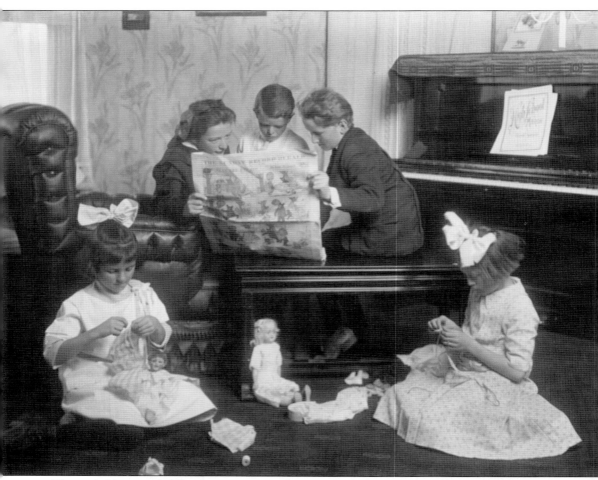

Three children, probably relatives, join Katharine Booth (lower left) and Edward Booth (upper right) for this photograph. An upright piano, piano bench, and comfortable chair furnish the room. Carpet and wallpaper patterns are also visible. Three of the children are reading the *Sunday Record Herald* as the younger girls play with dolls.

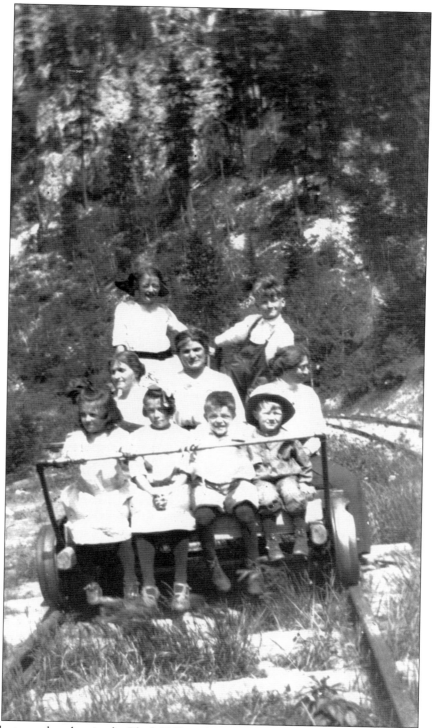

In this photograph, taken in the Black Hills near Victoria Spur, Katharine Booth (front left) and others pose on an old railroad handcar.

Construction began in 1905 on a large earthen dam on the Belle Fourche River north of the Spearfish hatchery. This Bureau of Reclamation project provided water for irrigation. The Booth children went along on the trip to stock the reservoir with fish. Roy Patterson's truck was loaded with milk cans filled with young fish. Crews carried the heavy cans to the shore before rolling up the legs of their pants to wade into the water. D.C. Booth recommended stocking it with steelhead trout, among other fish.

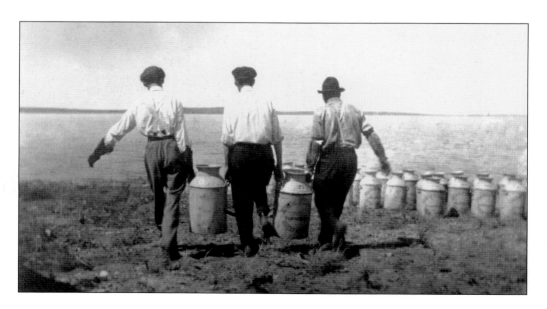

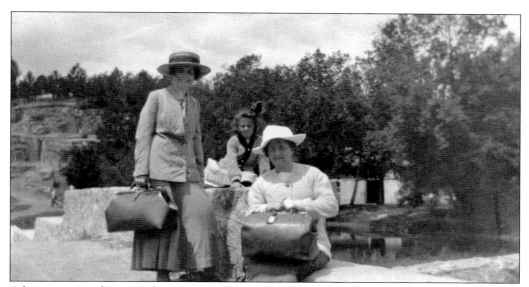

After returning from a sightseeing trip, Booth family members pose on the stone arch bridge at the entrance to the hatchery. Traveling light, they each hold a single piece of luggage. Ruby Booth is on the right, Katharine is in the middle, and the woman on the left is probably Ruby's sister Katharine "Kit" Hine. Kit spent many vacations in Spearfish.

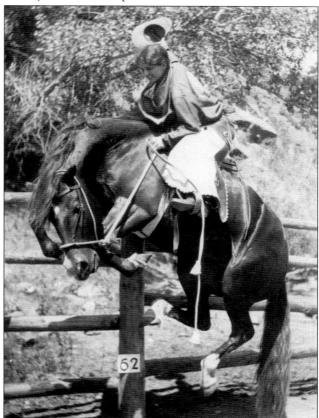

Kay, as Katharine Booth was called by her family, rides a horse named Dynamite in Deadwood, South Dakota. Dynamite was a taxidermied horse fastened to the fence in a realistic fashion for tourist photographs. Stuffed bucking horses were common in western tourist areas.

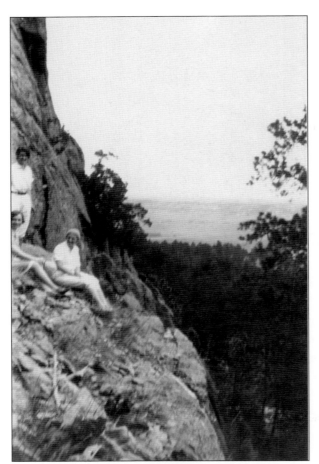

Katharine and friends pose on Devil's Tower in nearby Wyoming. From that height, the view must have been spectacular.

When photography started to become more widespread in the early 20th century, personal cameras began to be both affordable and popular, and the resulting images document the lives of hatchery families ranging from the Booths to those who still reside at hatcheries today. The Fassbenders were professional photographers, but they also developed film taken by others. Noted in pencil on this envelope is "Mr. Booth, 57 cents."

O.A. Vik, another professional photographer in the Spearfish area, also developed the film of others. Vik published postcards, as did Josef Fassbender. For a time, Fassbender worked for Vik when he came to Spearfish around 1923. Fassbender later opened his own photography shop, which came to be known as Black Hills Studios. The shop was operated by his son George into the 1990s.

Physical changes to the grounds and structures help archivists put photographs from a variety of sources into chronological order. In this photograph of the Spearfish superintendent's residence, vegetation is overtaking the house, and three unknown people stand in front of it. Tracks to the left of the house appear to be from a motorized vehicle rather than a horse-drawn conveyance. Based on the concrete surfacing (as well as curbing) in front, this shot may have been taken around 1917.

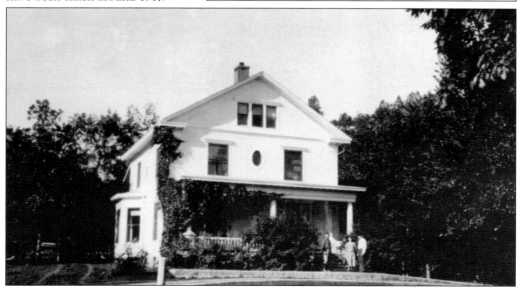

This image of the Spearfish superintendent's residence has a mystique. Stamped on the back are the name and address of Dr. "G.E. Mordoff," the principal figure in the bizarre "Sonny Boy" custody trial in Chicago that made national news in the early 1930s. Mordoff may have visited the hatchery and later sent a photograph to D.C. Booth as a courtesy.

In the image at right, a coverall-clad Edward Booth appears to be working on the engine of a biplane parked in a grassy field. In the photograph below, Edward, with goggles raised, sits in the back of the *Black Hills* biplane, possibly with D.C. Booth in the front ready for takeoff with goggles partially hiding his face. The location and biplane appear to be the same in both photographs.

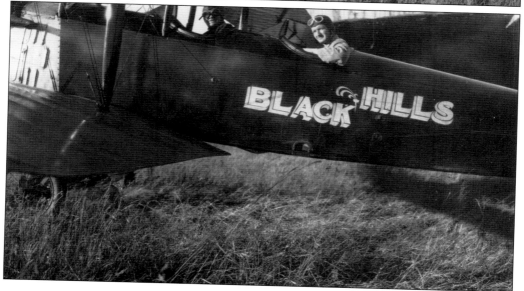

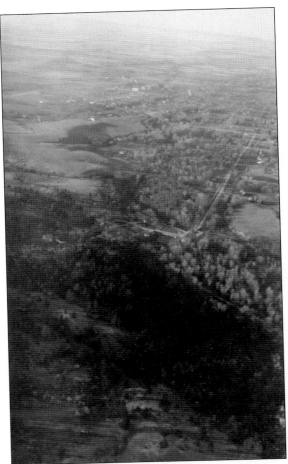

This is perhaps one of the first aerial photographs of the Spearfish hatchery. The ponds, hatchery building, superintendent's residence, and the small residence near the entrance are all visible. The small residence was constructed by 1938. The upper reservoir, the former site of board-lined raceways, is filled with water, and the 1939 WPA house has yet to be constructed.

With Lookout Mountain shown at the top, the 1926 high school stands out in the right center of the photograph. Spearfish Creek runs along the bottom of the image. The hatchery is not visible, located just out of view to the lower right.

Edward Booth, shown here in his West Point uniform, graduated in 1924 as a 2nd lieutenant in the Army Air Corps. He earned his nickname "Doc" while at West Point. He resigned from the Air Corps in 1929 and worked for Pan American Airways before opening a pioneering private aircraft sales and service company, counting on the growing use of airplanes in business and industry.

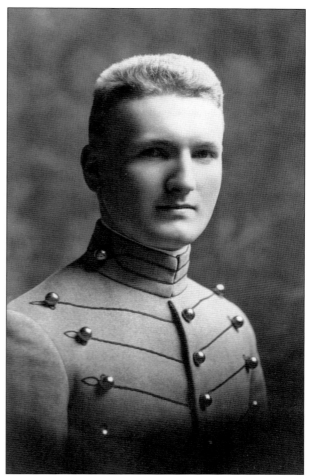

Little is known about this photograph, which is captioned "Our Gypsy Wagon." The balancing gypsy on the left bears some resemblance to Katharine Booth, but her identity is not confirmed, and the location where this was taken is unknown. Katharine graduated from the University of Michigan with a degree in mathematics. After graduation, she worked for various companies in Detroit and Chicago. Prior to 1928, the Black Hills college homecoming parade was called Pioneer Day, Gypsy Day, and Hobo Day. It is now known as Swarm Day.

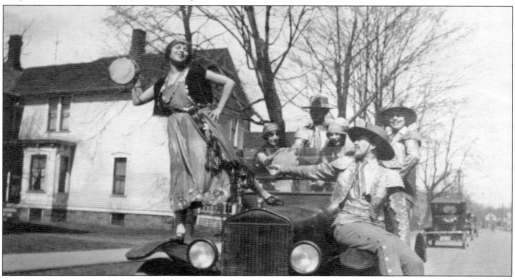

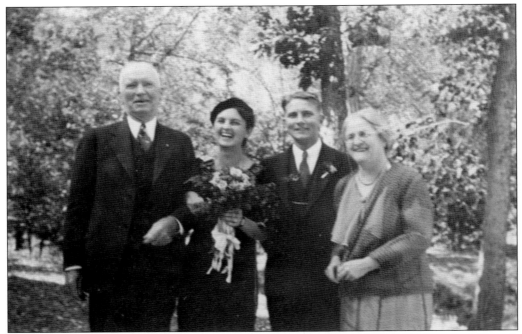

On October 5, 1933, Katharine Booth married Herman Mueller at All Angel's Episcopal Church in Spearfish. This photograph was taken later that day at the hatchery. From left to right are D.C. Booth, Katharine, Herman, and Ruby Booth.

This photograph is labeled "Rock Ledge" and is dated May 25, 1934. It is the retirement home of Ruby and D.C. Booth, which was close to the hatchery grounds. A white fence marks the edge of the hatchery water supply, and the hatchery grounds are to the right.

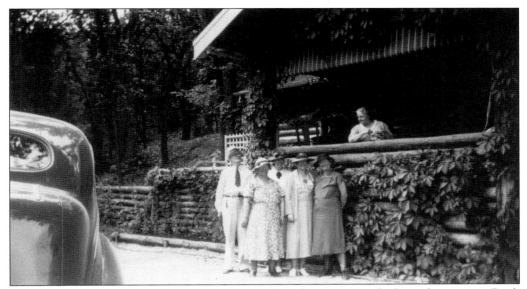

In this c. 1936 image, Ruby Booth (on the porch) welcomes properly dressed visitors at Rock Ledge, D.C. and Ruby's retirement house. Woodbine still grows on the hatchery grounds. Roll-down shades protected this porch.

A young Joan Katharine Mueller, daughter of Katharine and Herman, stands on the porch at the Booth retirement home.

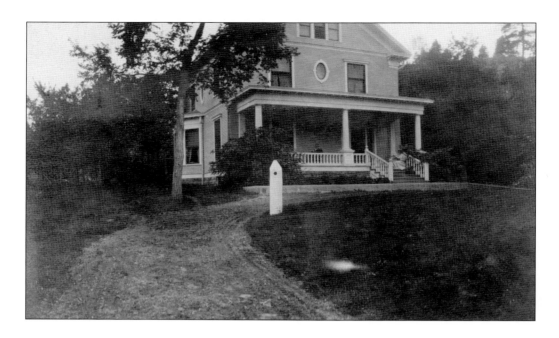

The people in the c. 1916 photograph above, taken at the superintendent's residence, are likely William E. and Bessie Smith. Superintendent Smith transferred from the Homer, Minnesota, hatchery, in December 1915, while D.C. Booth transferred to Homer. Smith died of pneumonia at home on January 5, 1918. He was active in the community while at Spearfish, including the Masons and the Boy Scouts. Booth returned to Spearfish on January 22, 1918. During Smith's brief tenure, the hatchery converted from horsepower to gasoline. The horse team and harness were transferred to the military post at Fort Meade, South Dakota, and the wagons were sold; soon after, a one-ton Ford truck, which cost $782, came to the hatchery, seen below.

Standing on the wooden steps of the superintendent's residence, this unidentified young boy and his dog likely lived in the house. The hatchery was probably on the route of a local milkman, as empty bottles on the porch are waiting to be replaced with full ones. Annual reports from the Spearfish hatchery usually listed employees by name, along with each person's number of dependents. In the 1930s, possibly when this photograph was taken, hatchery workers Charles Fuqua, Theodore S. Kibbe, and Loyd Justus were recorded as having children.

Leonard Hunt, pictured in front of the hatchery building porch, worked at the Spearfish hatchery by 1932. In this image, Hunt's family dog looks for attention from Leonard's wife, Luella. The Hunts were at Spearfish while the WPA house was built and apparently moved from the three-room apartment in the hatchery building into the WPA house when it was available.

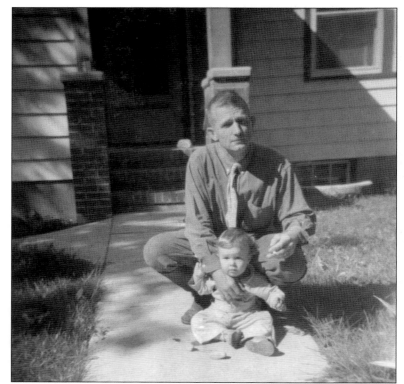

Leonard Hunt and son Lenny are pictured around 1940 in front of the WPA house. The original brick porch is visible. A smaller brick porch was at the back door. Both porches were replaced about 40 years later with wooden structures.

Dressed in a snowsuit, Lenny Hunt looks at the camera near the WPA house.

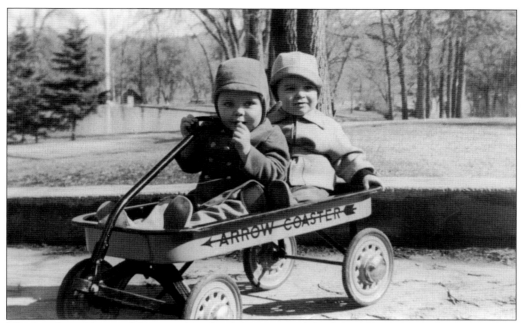

The families of Leonard Hunt and Richard O. Jones each had a small son when this photograph was taken. The Arrow coaster wagon was the modern wagon for its time. Wagons were popular toys at the hatchery.

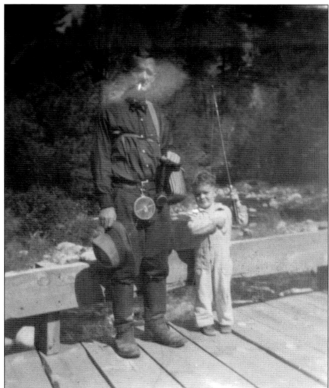

Despite being around fish all day, hatchery workers still love to fish. In this image, Leonard Hunt and son Lenny, laden with all the required gear, prepare to head out.

Lenny Hunt stands in front of an empty reservoir with the hatchery building in the background. The reservoir supplied water to hatchery facilities until new construction made it unnecessary. In 1951, it was filled in and became the site of the Collection Management Facility in 1994.

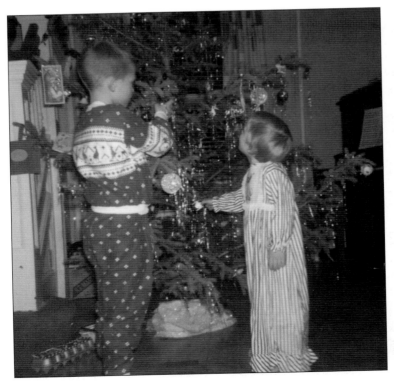

Joe Mazuranich was a hatchery manager in the 1960s. He lived with his wife, Erlene, and four children in the superintendent's residence. Interior decorating styles change over time. In this 1967 photograph, Devin and Nita Mazuranich help with the Christmas tree, complete with tinsel, in the foyer of the house. On the left are the stairs to the second floor, and the family piano is on the right, tucked behind the front door.

Glen Mazuranich turned 10 years old on March 12, 1968. Sheer curtains and plants decorated the dining-room windows in the superintendent's residence. From left to right, siblings Nita, Glen, Devin, and Bruce gather for a photograph.

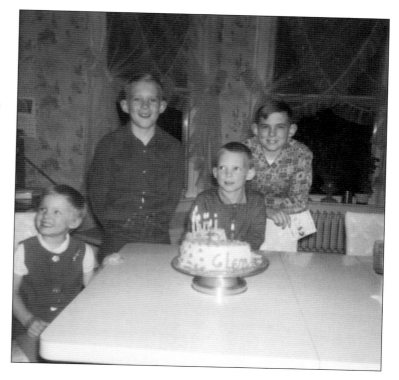

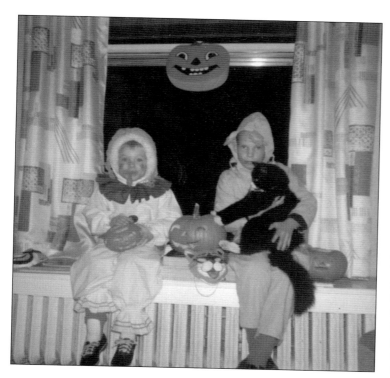

Clown Nita (left) and lion Devin Mazuranich (holding Elmer), dressed for trick-or-treating, are seated on a radiator cover in the superintendent's residence on Halloween in 1968. Halloween decorations abound, especially carved pumpkins. Geometric curtains lend a modern touch to an old house.

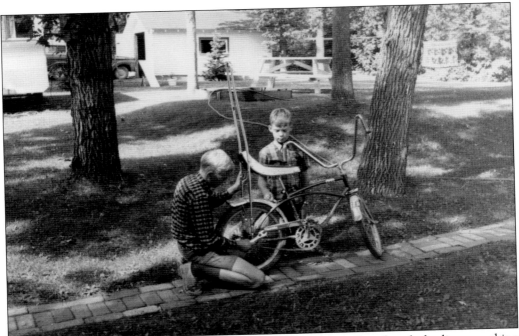

In 1971, the backyard of the superintendent's residence was typical, with a clothesline, a parking space for the family's small house trailer, a picnic table, and space for Glen and Devin Mazuranich to work on a bicycle. In the back is the family frame-construction, single-car garage with a concrete floor, built in 1933–1934. A china cabinet was built into a corner in the dining room at the same time, and built-in ironing boards were added to all the residences.

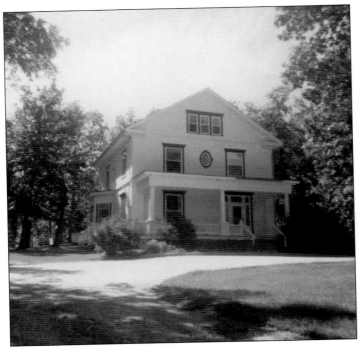

By 1965, the superintendent's residence was painted white with green trim. This same color scheme also appeared on some of the other hatchery buildings.

80

Three

Hatchery History in Postcards

It is not too bold of a prediction to assume that picture postcards will very soon be extinct as a means of communication. They will be relegated to a figurative dustbin alongside telegrams and typewritten letters. The reason for this is simple: advances in technology.

Most modern Americans can create "postcards" with relative ease. A person sees something interesting—a pretty place, one's children in rare form, or an event unfolding before one's eyes—and snaps an image or a short video with a digital device and sends it along with a text message or an e-mail. Or perhaps they just save it for themselves.

Such was the case with the postcards of yesteryear. They captured a scene that a tourist deemed worthy of saving and had printed onto postcard stock, or professional photographers captured images tourists would buy that could ultimately put money into the photographer's pocket.

No matter the motivation, professional and amateur photographers alike unknowingly documented different angles and aspects of Spearfish National Fish Hatchery over time, showing momentous occasions, handsome buildings, and pretty scenes. In the aggregate, they show enduring structures, the Hector von Bayer hatchery building, the superintendent's home, and the changes that time has wrought around them.

Many of these postcards are blank on the back, but those that were used tell stories of a different nature—the human experience—about deaths and births and hopes for rebirths. One describes the value of reading under kerosene light. Some missives are touching, while others are cryptic and mysterious with the absence of context and relationships of the writers and intended readers.

It is surely a matter of taste, but there is arguably a greater beauty in the sinuous handwriting of a message on an old postcard made out to a friend or relative than in the stale pixel-script of an e-mail typed out with thumbs and replete with typographical errors.

For those postcards that originated from the Spearfish National Fish Hatchery, there is beauty to be found on both sides; they convey to the viewer something about the past while also helping to inform the future.

—Craig Springer

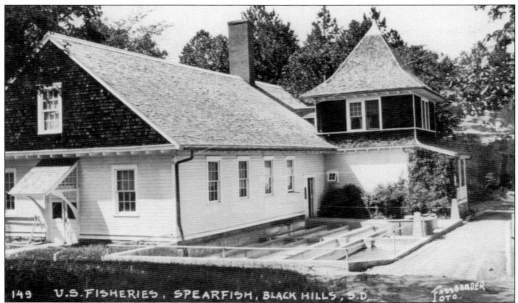

When US Fish Commission architect and engineer Hector von Bayer drew up the plans for this building, he created two-dimensional art in a blueprint. That work was transformed into three-dimensional art in the form of a beautiful building that is now known as the Hector von Bayer Museum of Fish Culture. Photographer Josef Fassbender created this postcard for the tourist market.

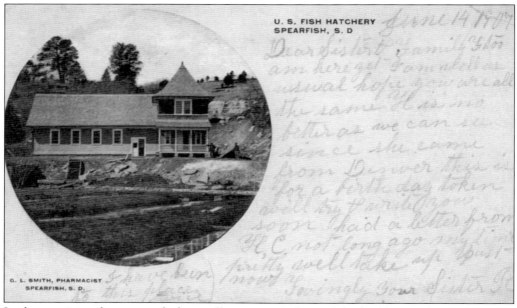

In the image on this postcard, the small raceways in front of the building no longer exist and have been replaced with a walkway. The building in the postcard appears much newer, although it was only six years old at the time, with much less vegetation in front. The writer notes to her sister: "I have been to this place twice."

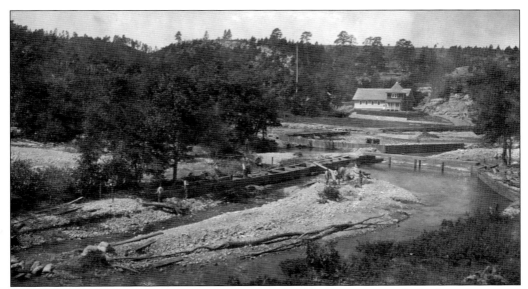

The men shown in this postcard appear to be at work. What is written on the back is a bit cryptic and somewhat startling and certainly not meant for communicating a happy affair associated with tourism. In pen, the sender wrote: "From Mabel E. Scott, Spearfish, S. Dak.," and toward the margin it reads, "died Nov 15 1908, 28 years old" and nothing more.

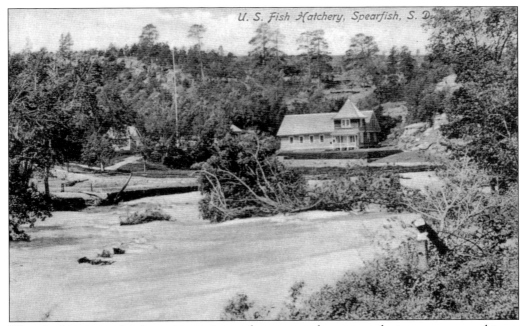

Though this postcard is less crisp an image than some other postcards, it conveys something a bit dark. The lower part of the hatchery was prone to flooding, as captured here. No doubt this flood was a momentous episode, as clearly shown by the damage apparent in the foreground.

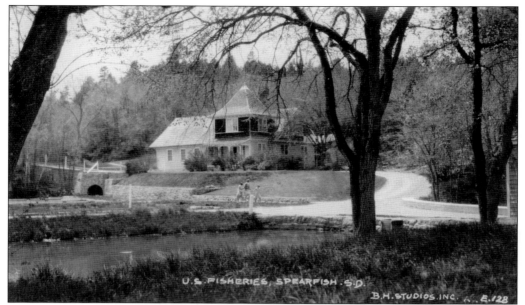

Much about the old Spearfish National Fish Hatchery remains as it was and as such has much to do with the site being listed in the National Register of Historic Places in 1978. In the above photograph, visitors appear to be strolling on the walkway in front of the old hatchery building. Today, in the grassy foreground, the old is juxtaposed with the new with an array of solar panels that collects the energy of the sun. The colorized postcard below shows "what was," which can be compared to "what is." The superintendent's residence (far left) remains there today. Behind the small, steep-pitched icehouse (where the replica fish car sits today), the reservoir is gone, filled in so to speak with the Collections Management Facility that is full of documents and objects pertaining to the history of fisheries across the country.

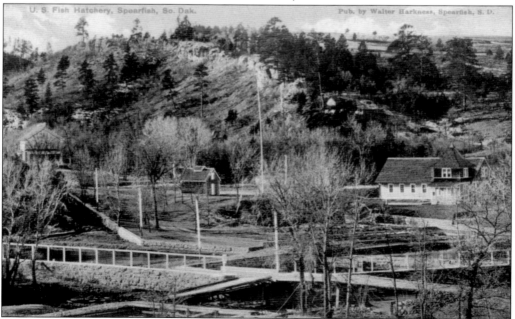

Four

Era of Change

Governments love to reorganize, and in 1939 and 1940, a big change came for the Spearfish hatchery. The US Bureau of Fisheries, in the Department of Commerce, and the Biological Survey, in the Department of Agriculture, merged under the Department of the Interior to form today's US Fish and Wildlife Service. The Bureau of Fisheries logo, a white fish on a red diamond over a dark blue field, used on official flags and china and other items was no more.

Water continued to be an issue at Spearfish. The original springs had fluctuated in quantity almost from the beginning. The auxiliary hatchery, built by the WPA in 1937, also had water quality problems. Heavy rain up the canyon would wash silt and heavy metals into the troughs, smothering eggs. Filters were tried, but they clogged quickly. A settling basin did not help enough. World War II affected hatchery operations, and plans to find a better location to hatch eggs were put on hold.

In 1941, the Spearfish hatchery was transferred from the Division of Fish Hatcheries to the Division of Fishery Biology. In anticipation of water quality issues resulting from war manufacturing, the Section of Water Quality expanded under this new division. The Columbia, Missouri, lab, under the direction of Dr. Max Mapes Ellis, supervised the new water quality lab at Spearfish. Richard O. Jones transferred to Spearfish as superintendent, taking on responsibilities regarding water quality research as well as trout production. The hatchery transferred back to the Division of Fish Hatcheries in mid-1947.

With fish production once again being the hatchery's prime function and the war at an end, the Spearfish hatchery needed a better solution to the water supply problem. In 1949, the US Fish and Wildlife Service and the State of South Dakota signed an agreement to use nearby state land for a federal hatchery. In return, 60 percent of the pounds of fish produced were to be stocked in South Dakota. Construction started in 1949 on Unit 2 of the Spearfish National Fish Hatchery. The land had been donated to the state for fish and wildlife preservation by Judge James McNenny, and Unit 2 became known as the McNenny National Fish Hatchery.

Fish production shifted to the new McNenny substation, with Spearfish being used for growing larger fish. Changes in stocking needs often required larger fish, which necessitated longer growing periods and more space. Spearfish and McNenny became the site of a national nine-and-a-half month school for fish culturists, as well as the Diet Testing and Development Center, helping both fisheries to make their marks in improving conservation. Still, more changes were to come.

—Randi Sue Smith

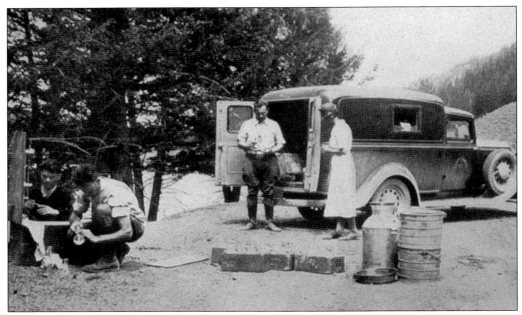

Arthur Hale was assigned to Spearfish in June 1942 as an aquatic biologist. His service was interrupted by World War II when he enlisted in the Army Air Corps in September of that year. Hale returned to Spearfish in April 1946. He and his wife, Ione, lived in the small house by Pond 1 with their daughter, Barbara. Panel trucks, such as the one pictured, were equipped for streamside water analysis with exacting chemical solutions and procedures.

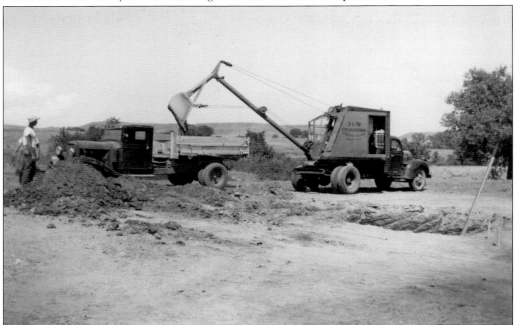

In this image from August 10, 1949, men use equipment to excavate for the basement of the first house at the McNenny substation. The first residence was wooden and built in a much different style from the two houses and hatchery building constructed a year or two later.

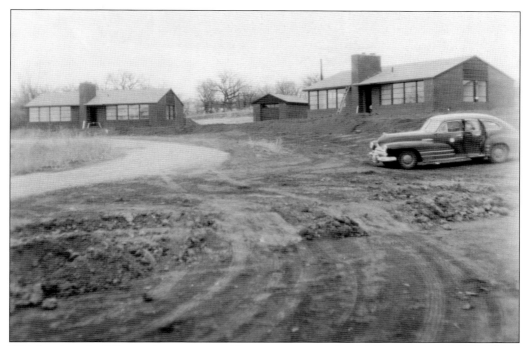

This hatchery building and two more residences were erected at McNenny around 1951. These buildings had brick exteriors and large window areas. It was a very different style from the first house and quite a contrast to the first buildings at the older Spearfish National Fish Hatchery.

Here, the main hatchery building at the McNenny substation looks nearly finished. The caption on the back reads, "No steeple?" implying that it looked church-like or perhaps was intended to have some sort of architectural spire.

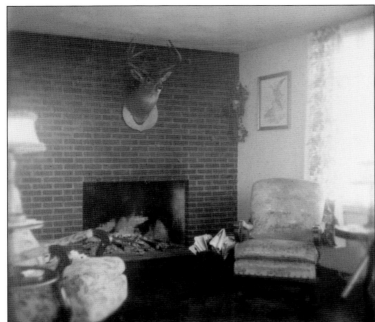

Hatchery employees typically like to hunt and fish, and their home furnishings frequently reflect this. This living room at the McNenny substation has a mounted big-game trophy head over the fireplace.

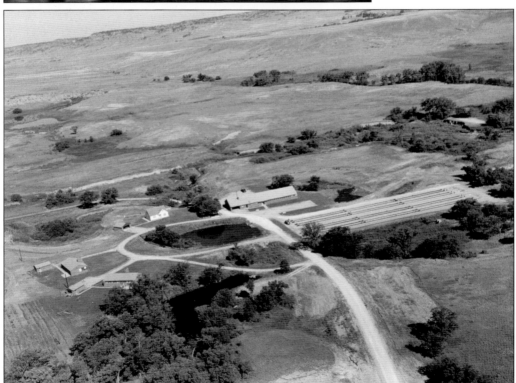

This early aerial photograph of the McNenny substation shows its main structures. The three residences are on the left, with the raceways and main hatchery building visible on the right and in the center, respectively.

Fish food is carefully weighed out for each raceway: too much and there would be waste, while too little would slow the growth of the fish.

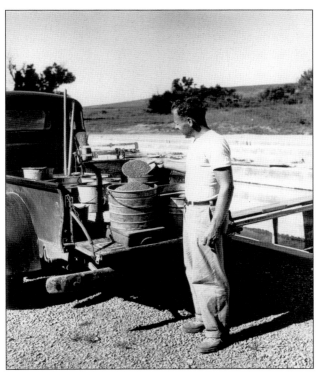

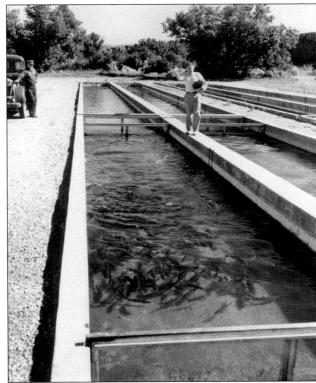

Here, pelleted fish food is dispersed by hand to feed large trout in a raceway. Too much food in one spot would be wasteful.

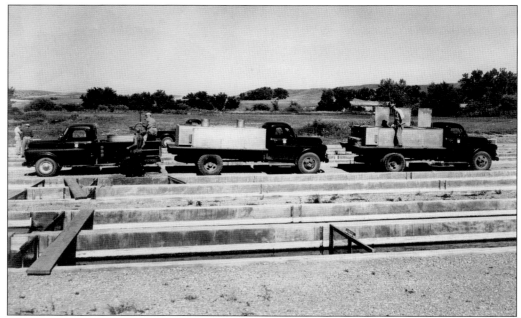

Fish were initially brought from the Spearfish hatchery to the new Unit 2 at McNenny around 1950. Parked along the new concrete raceways, the lead distribution truck on the right has a three-compartment tank with lids in the open position. Fearnow pails are on the back of the truck, as well as on top of the truck in the center. The truck on the left has a portable, open tank with a platform scale. Fish were counted by weight, by counting the number of fish in a few nets, by weighing the nets, and by figuring an average number of fish per pound. Adding up the weights of each net moved helped a worker estimate the number of fish in transit.

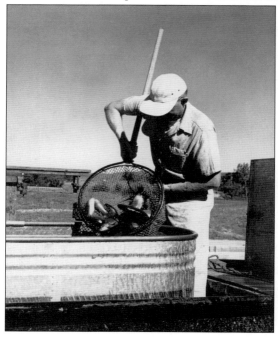

Fish were counted by weight after being snagged from the open tank with a dip net.

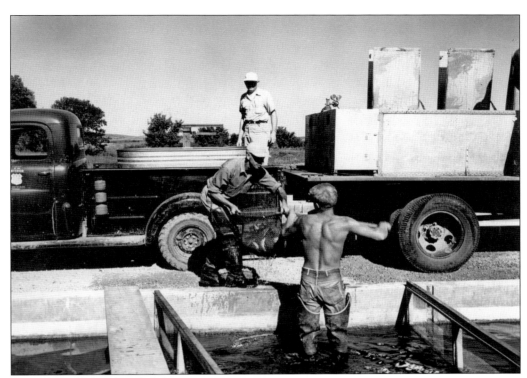

A net full of fish is handed down to a wader-clad worker in the raceway below to be dipped into the water. When moving fish, some of the staff usually had to get in the water in protective wet gear. Other staff members might stay relatively dry while reading the scale and adding up weights. Some staff might be in the middle moving nets of fish from one place to another and trying to stay dry.

Eggs masses are visible in this 1952 photograph of a brown trout. This may have been done to check for disease or for educational purposes.

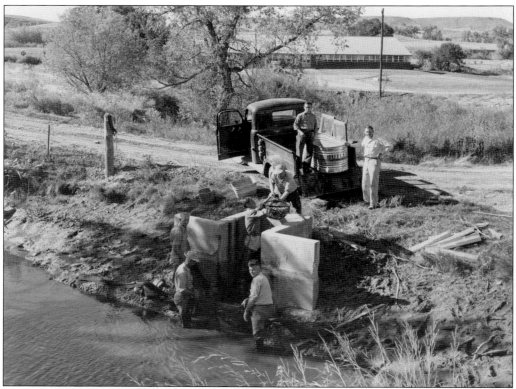

In this 1952 photograph, staff at the McNenny substation drain a pond and remove nine-inch trout with the hatchery building in the background. Pictured here are John Wege, Martin Juntti, Kenneth McIntosh, foreman Ollie Hawkins (holding net), Gail Sherin, Paul Pierce, and superintendent Harvey Willoughby.

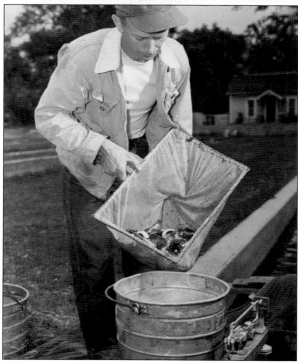

In this c. 1949 photograph taken by E.P. Haddon, Martin E. Juntti demonstrates weighing and moving fish. Haddon was a US Fish and Wildlife Service photographer. According to fisheries protocol, the container of water is first weighed before fish are added. An old Fearnow pail was used for the container. The small, single bedroom house at Spearfish is visible behind Juntti at the end of the raceways.

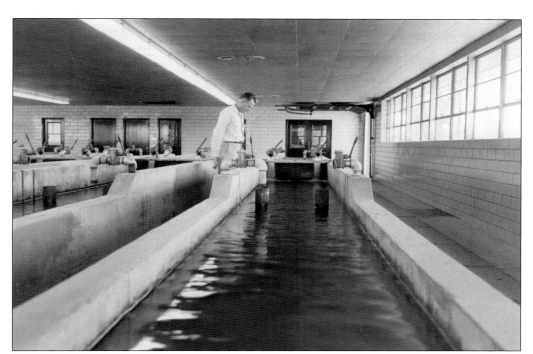

In this image, superintendent Harvey Willoughby looks over the fish inside the McNenny substation. Water flowed at 80 gallons per minute in these modern concrete troughs. At 30 feet in length and three feet in width, with a capacity of 27 inches of water, quite a few fish could be kept in the troughs.

Then, as now, thousands of people visit the hatchery each year. In 1950, South Dakota's Isabel High School visited the hatchery on Senior Skip Day. A member of the group, Elmer L. Myers, had a camera and took three photographs while at the hatchery. In this photograph, Clarence Ochsner, the other boy in the class of eight students, smiles for the camera. This view looks north over the concrete raceways and shows the barn in the left background.

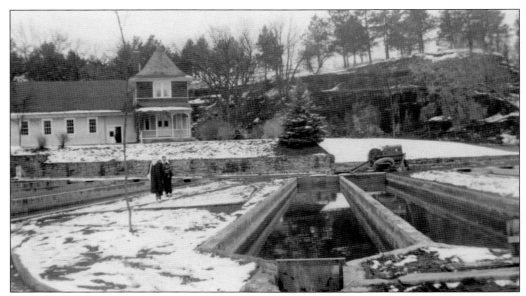

Isabel High School seniors were skipping class on May 7, 1950, when a hatchery worker saw them from the hatchery trough room doors, perhaps wondering what was going on. The pump unit at the end of the raceway was probably constructed on a pickup box.

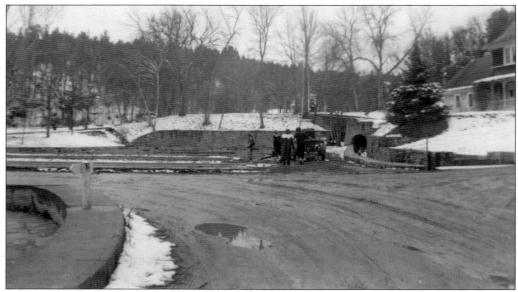

When this photograph was taken on May 7, 1950, snow was still on the ground, melting into a muddy mess. Four senior students from Isabel High School—half the class—are picking their way along the raceways. The superintendent's residence and hatchery building are partially visible on the right.

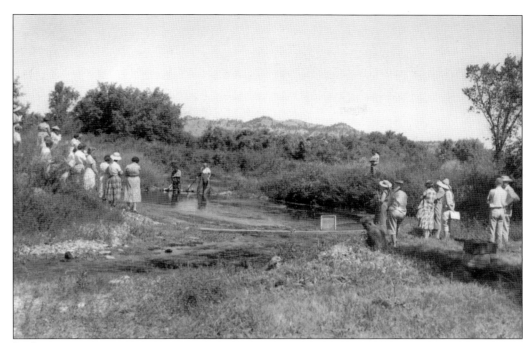

In this image, a science class from Black Hills State College (now Black Hills State University) visits the waters of the McNenny substation on a field trip. Staff members demonstrate fish culture techniques in one of the ponds as students look on.

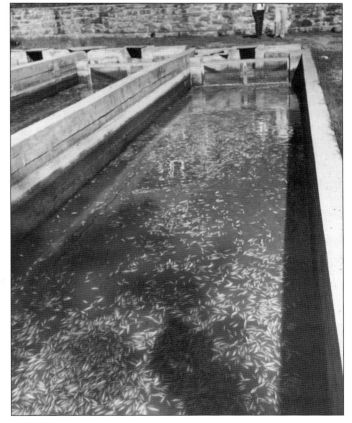

In June 1953, someone cut the water supply to the Spearfish hatchery, killing 118,000 rainbow trout. The three- to four-inch fish shown here had just been moved in from the McNenny substation. No one was able to determine who shut the water off, but speculation was that children were playing or someone tried to cut the water to catch stranded fish.

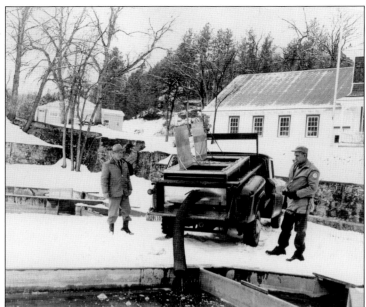

In this image from the spring of 1963, Norman Anderson (left) and Gene Mason demonstrate a new transfer tank at Spearfish. With a hydraulic lift on the Chevrolet truck, the tank could be tilted to quickly drain the fish down a tube into a pond or raceway. In the background is a structure the US Forest Service used to house some staff in 1959. The hatchery building was also later used as offices for the US Forest Service.

Harry Willard (left) and Gene Mason demonstrate the ease of moving the new transfer tank—when it was empty. Tanks on the trucks kept the fish supplied with oxygen during transport. The Spearfish hatchery building is partially visible on the right.

In this image from August 13, 1964, Chuck Sowards marks a brown trout at the Spearfish National Fish Hatchery after it was anesthetized in quinaldine. Tagging and marking fish are essential techniques for biologists to gather a wide variety of information related to fisheries management and research, including migration patterns, population estimates, fish growth, and mortality.

In this May 1965 image, staff at McNenny weigh rainbow trout and load them for transport using a trailer-mounted scale towed by a small tractor. Ben Schley, who was in charge of fish hatcheries for the US Fish and Wildlife Service, took the photograph. Much like when the Spearfish hatchery made Pres. Calvin Coolidge's visit to the Black Hills memorable, Schley once stocked a stream for Pres. Dwight Eisenhower at the request of the Secret Service.

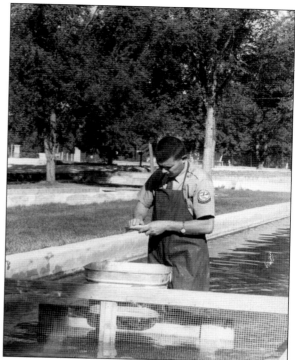

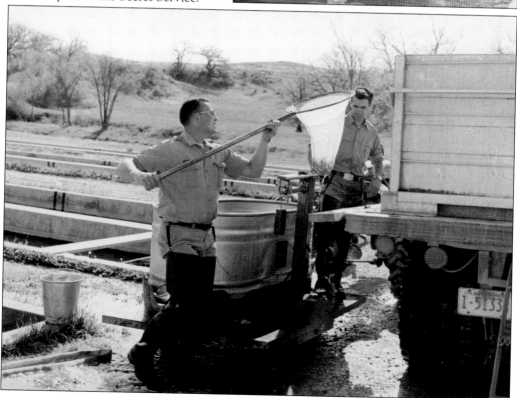

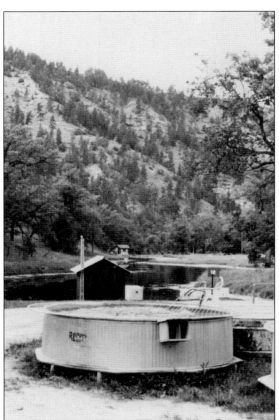

Sand Creek, Wyoming, had a trout hatchery for many years that worked cooperatively with the Spearfish hatchery. Pres. Calvin Coolidge fished Sand Creek in 1927. Moses Annenberg, a wealthy newspaper owner, built a large summer home known as Ranch A on the creek. The US Fish and Wildlife Service purchased the site in 1963 for a Fish Genetics Lab, and it was added to the Spearfish Fisheries Complex in 1980. The property was transferred to the State of Wyoming in 1997. An outdoor tank sits near the creek.

In this c. 1973 image, Frank Wichers stands by the new glass doors at the Spearfish hatchery. The building was remodeled for the "Long Course" fish culture school. The floor was raised in the trough room, and heat ducts and electrical wiring were installed underneath. A new ceiling, lighting, and furnace were also installed. The trough room had a lecture room, a laboratory, and six study rooms, along with three offices and a library. Tables were covered in white laminate with gold flecks, which was quite stylish for the time.

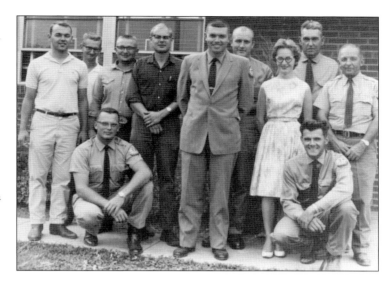

In this 1969 image, hatchery and diet center staff members pose outside the hatchery building at McNenny. The Diet Testing and Development Center existed from 1966 to 1981. Its directors included Charles Sowards, Warren Shanks, Leo Orme, and Gary Reinitz. Its mission was to develop pelleted feed for cold-water fish, and it helped solve feed problems in Chile, Japan, and France.

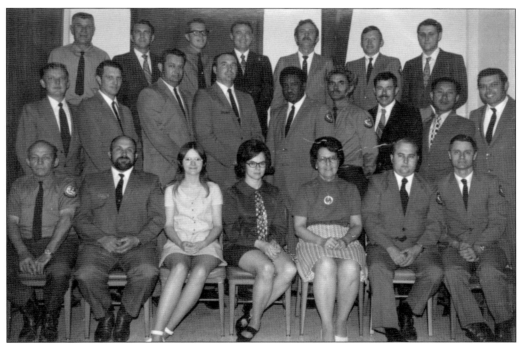

The In-Service Training School for the US Fish and Wildlife Service transferred from Cortland, New York, to Spearfish in July 1967. Long-course students and their families moved to Spearfish and became part of the community for nine months. The instruction included class work and research projects, along with work assignments at Spearfish and McNenny. Instructors from across the country supplemented the Spearfish Fisheries Complex staff. The last long-course class, along with staff, posed for this formal picture in 1972.

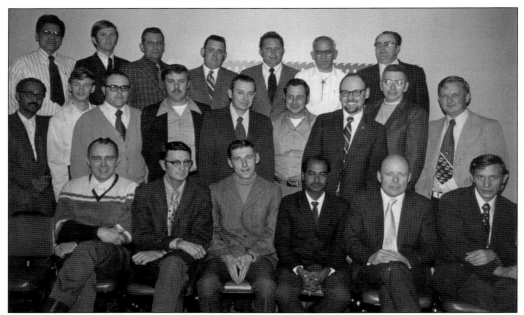

After 1972, Spearfish offered a two-week-long course. Identified here are students and instructors including Al Sandvol, Bob Piper, Bill Whiting, and Dale Lamberton. The empty chair on the left was waiting for Chuck Sowards, superintendent of the Spearfish Fisheries Complex.

Fish diet researchers stand outside the McNenny substation's hatchery building in this 1973 image. From left to right are Diet Development Center director Leo Orme, Carol Lemm, Frances Hitzel, and Roger Schulz. The Spearfish Fisheries Center was Schulz's first assignment in the US Fish and Wildlife Service in a career that wended through many decades and several national fish hatcheries and leadership positions.

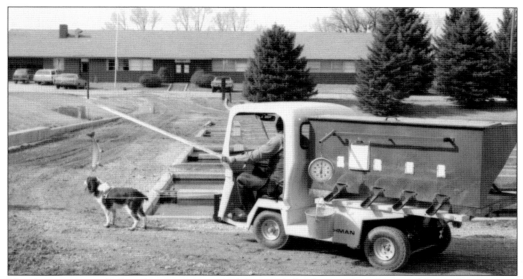

Hatcheries responded to the energy crisis of the 1970s by doing what they could to reduce energy consumption. In a moment of levity, staff experiment with an alternative power source for this vehicle, a small cart used to carry fish food to raceways at the McNenny unit.

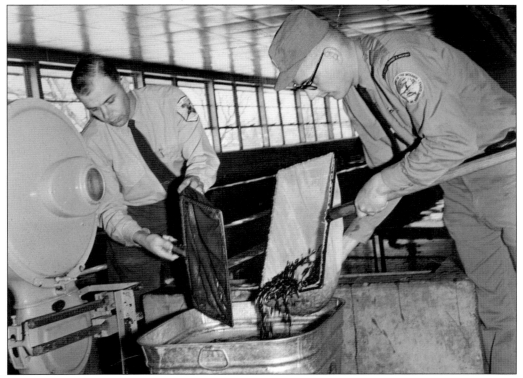

In this photograph taken inside the McNenny substation, a South Dakota Game, Fish, and Parks employee works on a joint project with a US Fish and Wildlife Service biologist; the two men are moving fingerling trout with a scale nearby. These short, rectangular nets worked well with rectangular troughs in the confines of a hatchery.

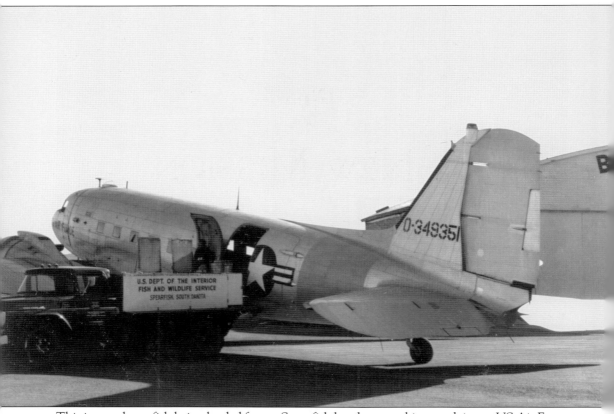

This image shows fish being loaded from a Spearfish hatchery stocking truck into a US Air Force plane at the Spearfish Black Hills Airport. Surprisingly, dropping fish from planes and helicopters is an efficient way to stock fish, particularly in remote areas.

Five

A NEW MISSION

After a very successful fish production history, federal budget cuts forced the closure of the Spearfish Fisheries Complex in 1983. The US Fish and Wildlife Service transferred the McNenny substation to the South Dakota Game, Fish, and Parks, where it remains vital to Black Hills trout management.

The US Fish and Wildlife Service retained Spearfish National Fish Hatchery, the Ranch A Fish Genetics Lab, and the Diet Development Center for a time but eventually ceased operations in 1986. The City of Spearfish was allowed to use the Spearfish National Fish Hatchery as a tourist attraction while maintaining the old hatchery building, which was converted into a fisheries history museum by the service in 1982. Volunteers from the community operated a gift shop out of the 1899 structure and formed the Booth Society, Inc., to serve as a financial and preservation conduit.

In 1989, the US Fish and Wildlife Service resumed operations in Spearfish with a new mission. Today, the D.C. Booth Historic National Fish Hatchery and Archives serves as a living fisheries museum. Still raising trout for the Black Hills in cooperation with the McNenny State Hatchery, the archive collects, preserves, and protects fisheries records and artifacts for educational, research, and historical purposes and provides interpretive and educational programs for everyone. To modernize the station, Congress funded a state-of-the-art collection management facility—the first of its kind in the US Fish and Wildlife Service—that includes administrative offices, a concessions building, an underwater viewing area, and public restrooms.

The collections at D.C. Booth Historic National Fish Hatchery and Archives continue to grow. Currently, about 15,000 objects and 160,000 pieces of irreplaceable archival material are preserved and protected in a 10,000-square-foot, climate-controlled storage facility. Objects and documents are managed by professional curators and archivists.

The 10-acre site, listed in the National Register of Historic Places, receives over 155,000 visitors each year. The Booth Society, Inc., remains a strong partner in fundraising, providing volunteer and visitor services, conducting tours, and maintaining the grounds. The society has arguably become the US Fish and Wildlife Service's flagship Friends Group. Dedicated partners in the City of Spearfish, American Fisheries Society's Fish Culture Section, and the South Dakota Department of Game, Fish, and Parks keep the treasured D.C. Booth Historic National Fish Hatchery and Archives available for future generations.

—Carlos R. Martinez

Today, the historic 1899 hatchery building houses the Von Bayer Museum of Fish Culture and contains many exhibits chronicling the rich history of fisheries management and fish culture. The three flagpoles in front proudly display the flags of the former US Bureau of Fisheries, the Department of the Interior, and of course the United States. (Les Voorhis.)

The Collection Management Facility, built in 1995, currently houses an estimated 15,000 objects and 160,000 pieces of archival material that are preserved and protected in a 10,000-square-foot storage facility. It has a lab for working with museum objects, climate-controlled storage areas, and safeguards that offer the best possible protection for irreplaceable materials of national significance. The structure also houses some US Fish and Wildlife Service administrative offices.

Although the D.C. Booth archive focuses on American fish culture and fisheries management, a large number of rare artifacts relate to US Fish and Wildlife Service history, the National Wildlife Refuge system, and a variety of state conservation agencies.

The D.C. Booth archive is a unique resource dedicated to collecting, preserving, and providing access to documents related to fish culture, management, and conservation. The collection contains over 160,000 original architectural drawings, blueprints, photographs, and journals that tell the stories of American fisheries.

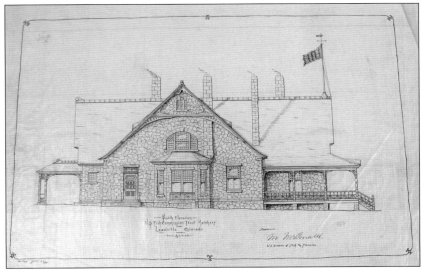

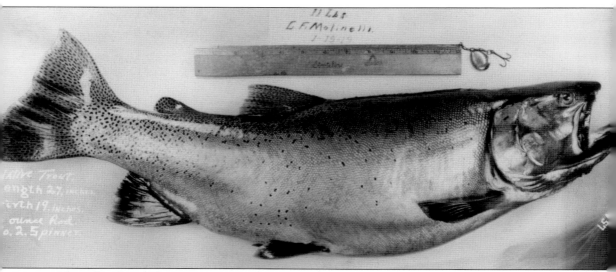

The yellowfin cutthroat trout, pictured here, is probably gone forever. It was only found in the Twin Lakes at the head of the Arkansas River near Leadville, Colorado. This 1919 photograph may be the only known image of the yellowfin cutthroat trout. This was the judgment of trout expert Dr. Robert Behnke; his opinion and the image itself are both preserved in the archives at D.C. Booth. By coincidence, Barton Warren Evermann, the US Fish Commission scientist who recommended Spearfish as a potential hatchery site, gave the yellowfin cutthroat trout its scientific name the year before he investigated the fisheries of the Black Hills.

Curator Randi Sue Smith has worked in the collection nearly since its genesis. For 21 years, she has curated the contents, which total about 175,000 items thus far. The items include things such as uniform badges, laid out in trays in the image below, clothing, and other items of fabric, including several wool flags featuring the logo of the former US Bureau of Fisheries. The flag shown at right may have adorned the mast of a ship that sailed the seas, the Great Lakes, or perhaps the Mississippi River. No matter where the ship sailed, its workers were engaged in some sort of fisheries activity.

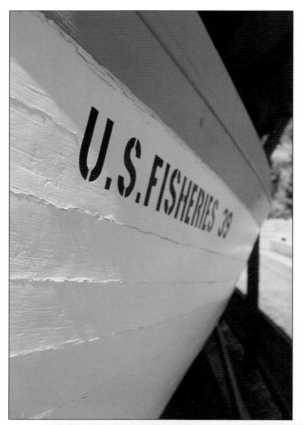

The archives holds items large and small. Although most are indoors, some are outside and within public view, like the restored vessel named *US Fisheries 39* (at left). This boat was used for fisheries work in Yellowstone National Park. The fish in the antique jar (below) rests in the basement of the archives; behind it is an old electro-fisher, an apparatus used to stun fish so that biologists could catch them alive for management and biological research purposes. In the foreground, a modern instrument measures temperature and humidity.

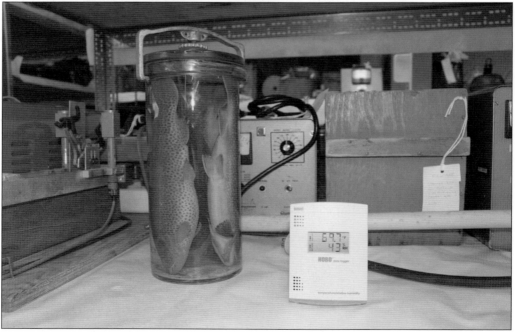

Periodically, unique items surface from the early days of the Spearfish National Fish Hatchery. Two examples are a silver spoon with the hatchery building engraved on it (above) and a saltshaker embossed with "U.S. Fisheries / Spearfish, S.D." and an image of the station (right). Both of these items are assumed to have been manufactured by private entities and marketed to tourists visiting the Black Hills.

Among the numerous items in the archive are one-of-a-kind, rare artifacts, with some dating to the mid-1850s. The smallest artifact in the collection is a bead for marking fish, and the largest is a fish distribution truck. Several decades are represented in these photographs showing a Starrett Transit surveying tool (left) and a historic hatchery journal and agency reports (right).

Technology both old and new is represented in this image of a dissolved oxygen meter placed alongside some antique fry nets.

Since 1871, numerous pieces of art have been used to illustrate the conservation work of the US Fish and Wildlife Service and its predecessor agencies. Naturally, numerous pieces are preserved at D.C. Booth Historic National Fish Hatchery and Archives. Of special importance is the art of Bob Hines. Hines was hired by the service in 1948 as an artist, a somewhat unusual and very rare occupation for the agency. His detailed oil paintings include a majestic eagle in *Symbol of Our Nation* (right) and a close-up of a Yellowstone cutthroat trout (below). The cutthroat appeared in the book *Sport Fishing USA*. The eagle was painted for the 1971 centennial of the US Fish and Wildlife Service and was available to the public on heavy paper for $1.85.

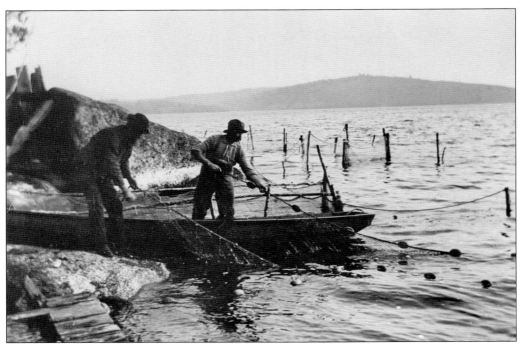

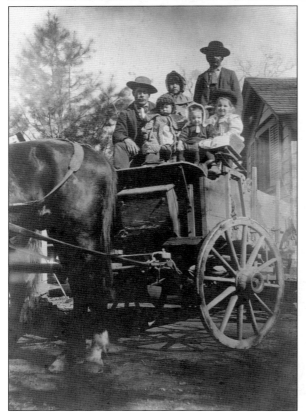

The lives, careers, and memories of individuals who made important impacts in the field of fisheries are preserved in the D.C. Booth archive. Biologist Charles Atkins's lifelong career in fisheries science led him to various parts of the world. He is shown above seining Atlantic salmon broodstock in Maine. In the image at left, hatchery employees and children pose on a US Fish Commission wagon at the Baird Fish Cultural Station, the country's first national fish hatchery.

The Fish Culture Hall of Fame is located in the 1899 replica icehouse at the D.C. Booth Fish Hatchery. Established in 1985 by the Fish Culture Section of the American Fisheries Society, the Fish Culture Hall of Fame is sanctioned by the US Fish and Wildlife Service and supported by the Booth Society, Inc. As of 2013, fifty-four notable contributors to the art and science of fish culture have been inducted into the hall of fame. The exhibit is popular among current and former employees of the country's various conservation agencies. Induction ceremonies (below) take place during Booth Day in May.

Livingston Stone, one of the most recognized fish culture pioneers, was instrumental in the establishment of the US Fish Commission, the precursor of today's US Fish and Wildlife Service. A photograph of him in his early years (at left) was made accessible by his great grandson Ned Kirstein. Stone was inducted into the Fish Culture Hall of Fame in 1989. His induction plaque (below) is on display in the station's 1899 icehouse replica. (At left, Livingston Stone Collection.)

LIVINGSTON STONE

Born in Massachusets in 1836, he graduated from Harvard in 1857, entered Meadville Theological School and was ordained a Unitarian Minister. He resigned his clergical duties in 1866 and began a career in fish culture. In 1898, he was recognized as America's Senior Fish Culturist.

In 1870, Livingston Stone was one of the founders of the American Fisheries Society, its first secretary and one of the drafters of its constitution.

In 1872, Stone was named U. S. Deputy Fish Commissioner and assigned to establish the Baird Hatchery in California. He published the classic fish culture book "Domesticated Trout" the same year and it soon became a standard manual for fish culture. In 1873, he was assigned the task of moving fish across the continent by railroad.

Stone early on recognized the interaction between the biological science and fish culture and was the first to recommend and request a trained biologist for hatchery staff. He was an early advocate of preserving historic salmon runs on both coasts and in 1892 asked the piercing question, "What hope is there for the salmon in the end?"

He is one of America's greatest fish culture pioneers, and an early advocate in establishing the Federal Fish Culture Program.

Enshrined into the "NATIONAL FISH CULTURE HALL OF FAME," Spearfish, South Dakota, 1989.

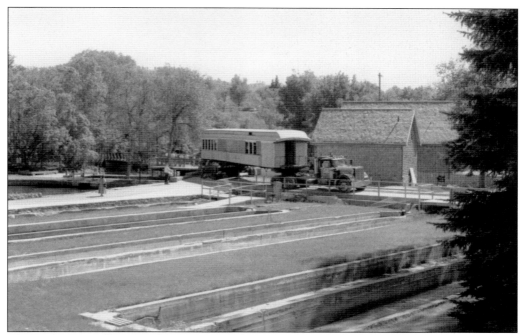

The Harlan & Hollingsworth Company built the replica of Fish Car No. 3 from a 1910 passenger car purchased from the Black Hills Central Railroad in Hill City, South Dakota. The 40-ton car had a similar body style, end platforms, and clerestory windows like those of the real Fish Car No. 3. A number of grants and numerous volunteer hours were critical for the completion of the popular exhibit.

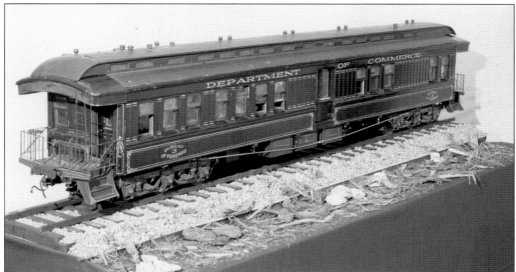

Replicating Fish Car No. 3 was made possible thanks to an antique model housed in the D.C. Booth archives. Built for $400 in 1897, the scale model has working doors, windows, and wheel assemblies. It was exhibited around the United States by the US Fish Commission and even made a trip to Paris. The Harlan & Hollingsworth Company, a prominent ship- and railroad-car manufacturing firm, produced both the model and the real Fish Car No. 3.

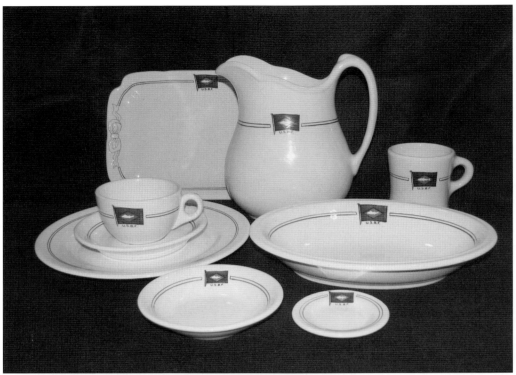

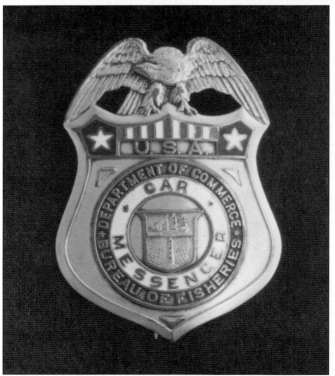

It is easy to find a number of artifacts related to the railroad era at the D.C. Booth Historic National Fish Hatchery. Beautiful and well-preserved specimens include a set of railcar china (above) and a messenger's badge (left).

Today, seven raceways exist at the D.C. Booth Historic National Fish Hatchery. Their design is different from raceways of other contemporary hatcheries, as these structures were constructed to look "old fashioned" and historically accurate. Because the entire facility is listed in the National Register of Historic Places, an effort has been made to avoid the technological improvements that affect historical aesthetics. These raceways are typically filled with water and fast-growing trout. The grassy lawns between them provide a perfect park-like space where visitors stroll along slowly, feeding and watching the trout. (Les Voorhis.)

A cooperative agreement with the South Dakota Game, Fish, and Parks still makes it possible to raise trout for Black Hills waters. Rainbow trout and brown trout grow in raceways and ponds. Once they reach optimal size, they are stocked in area lakes and streams, just as they were 100 years ago. These two images illustrate production fish being removed via dip nets from the same pond and location approximately 75 years apart. Note that the same outlet structure is visible on the right in each photograph.

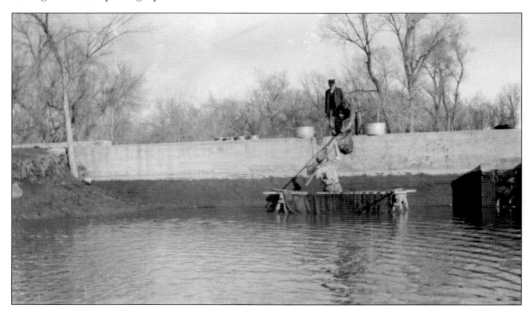

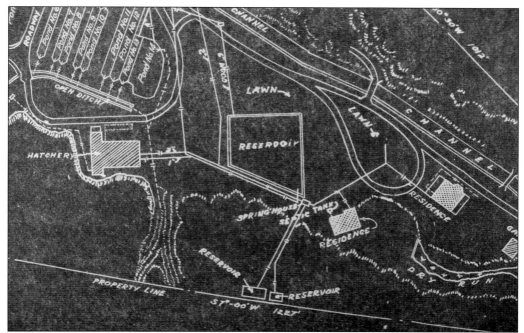

The entire hatchery site, which spans 10 acres, is listed in the National Register of Historic Places. Ponds, rock walls, water systems, and buildings contribute to the site's historic significance. Although many alterations have been made to the site over the years, each change tells a story about hatchery operations. This 1942 blueprint shows the location of the ponds and storage reservoir. The reservoir is now the site of the Collection Management Facility, home of the hatchery's administrative offices.

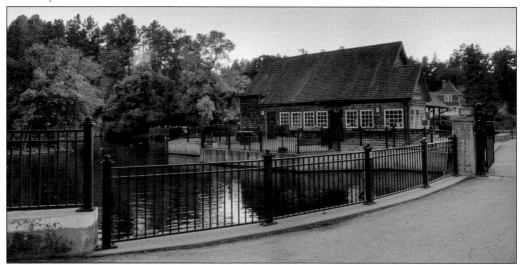

Volunteers manage and operate the Pond Shop gift store. Proceeds benefit the Booth Society, Inc., a nonprofit organization that strives to promote, preserve, and enhance the educational, cultural, and recreational opportunities at the D.C. Booth Historic National Fish Hatchery and Archives in cooperation with the US Fish and Wildlife Service. The most popular item sold in the gift shop is, of all things, food to feed the trout. (Les Voorhis.)

Today, visitors can get up close and personal with rainbow and brown trout through the underwater viewing windows constructed in 1994. Often mistaken for broodstock, the trout in this pond are not raised for eggs, nor are they stocked anywhere; they remain on site for viewing and educational purposes. Some of the trout are over eight years old and may weigh over 15 pounds. (Les Voorhis.)

Hatchery Helpers is a nationally recognized, award-winning program that allows students to learn about nature and conservation via experiences in volunteerism. The D.C. Booth Historic National Fish Hatchery and Archives benefits from over 14,000 volunteer hours each year from people of all ages and backgrounds.

Former superintendent Arden Trandahl (right) is credited with turning the Spearfish National Fish Hatchery into the D.C. Booth Historic National Fish Hatchery and Archives of today. After Trandahl's retirement in 1996, Steve Brimm (left) took charge and admirably led the facility until he retired in 2007, passing the reins to current superintendent Carlos R. Martinez (center). A fish biologist by training and a historian by habit, Martinez transferred to Spearfish from the Leadville National Fish Hatchery in Colorado, just as D.C. Booth did in 1899.

Stone structures built through the years deteriorate with time. In the 1972 image above, Alan Sandvol repairs stone walls as part of his duties as superintendent. The hatchery has experienced its fair share of floods throughout the years. One such event occurred in 2008 and severely damaged the stone flood channel. The station was fortunate to receive funding toward the repairs via the American Restoration and Recovery Act. Restoration crew members pictured below are, from left to right, Ronnie Little Bear, Trevor Olson, Nicki Shinkle, Tyler Hemmingson, Travis Langer, crew leader Mitch Adams, and Shaun Skavang.

The immaculate hatchery grounds have become a favorite location for photographers and artists. Renowned transparent watercolorist Jon Crane captured the historic hatchery building (above) and superintendent's residence (below) in great detail. The Booth Society, Inc., sells prints of these pieces in the Pond Shop gift store, with proceeds benefiting the fish hatchery. (Jon Crane.)

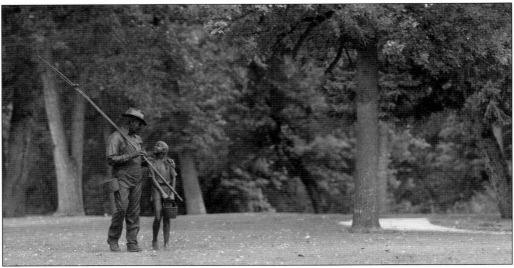

This sculpture, entitled *Generations*, represents the enduring cultural importance of fisheries conservation as a grandfather and granddaughter are depicted enjoying time together while fishing. This is a scene that many visitors can relate to, and the statue is a popular backdrop for family photographs. Sculptor James Michael Maher, of Belle Fourche, South Dakota, was commissioned by the Booth Society, Inc. to create this bronze piece for the 100th anniversary of the hatchery in 1996. (Les Voorhis.)

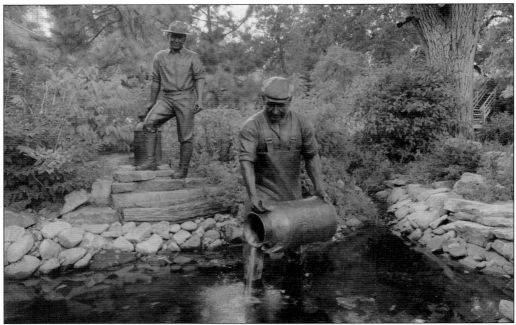

Frozen in bronze, *Spring Stocking* depicts two fishery workers using a period tool, milk cans, much like the historical image on the cover of this book. This artwork honors the dedication of early hatchery workers and their contributions to conserving the country's fisheries. The sculpture, by James Michael Maher, was completed in 2002 and paid for via fundraising by the Booth Society, Inc. (Les Voorhis.)

About the Booth Society, Inc.

In 1983, after 84 years of successful fish production, the federal government temporarily closed the Spearfish National Fish Hatchery. Spearfish-area residents were committed to preserving this important part of local heritage, and the City of Spearfish assumed management of the hatchery under an agreement with the US Fish and Wildlife Service.

The Spearfish City Council created the Hatchery Advisory Board to assist with the facility's preservation and historical, cultural, and educational development. The hatchery had always been a popular Spearfish attraction, and the intent was to enhance the facility as a tourist destination.

The Booth Society, Inc., an offshoot of the advisory board, was created to serve as a nonprofit financial arm of the operation. The society was committed to raising funds, developing interpretive displays, planning activities, and otherwise assisting in the promotion of the site and the museum collection. Officially incorporated on April 11, 1989, the Booth Society's original board of directors consisted of Arden Trandahl, Don Aaker, Herb Aslesen, Larry Capp, Madaline Custis, Lee Ervin, Rich Harr, Paul Higbee, Jim Kelley, Patricia Larson, David Miller, and Ruth Quinn.

As a result of the station's new partnerships and the enthusiasm shown by the Spearfish and Black Hills communities, the US Fish and Wildlife Service resumed operations at the hatchery in 1989 and renamed the facility the D.C. Booth Historic National Fish Hatchery and Archives. Additionally, Congress appropriated funding for construction of a state-of-the-art collection management facility, administrative offices, a concessions building, and an underwater viewing area.

Today, the Booth Society continues to promote, preserve, and enhance the educational, cultural, and recreational opportunities at the hatchery, in cooperation with the US Fish and Wildlife Service, for the benefit and enjoyment of the public. The Booth Society, the US Fish and Wildlife Service, and the City of Spearfish maintain a strong and influential partnership that makes this possible.

—April Gregory, Executive Director
Booth Society, Inc.

Discover Thousands of Local History Books
Featuring Millions of Vintage Images

Arcadia Publishing, the leading local history publisher in the United States, is committed to making history accessible and meaningful through publishing books that celebrate and preserve the heritage of America's people and places.

Find more books like this at
www.arcadiapublishing.com

Search for your hometown history, your old stomping grounds, and even your favorite sports team.

Consistent with our mission to preserve history on a local level, this book was printed in South Carolina on American-made paper and manufactured entirely in the United States. Products carrying the accredited Forest Stewardship Council (FSC) label are printed on 100 percent FSC-certified paper.